The Elgin Marbles

Also by Christopher Hitchens

*Prepared for the Worst: Selected Essays
and Minority Reports*

*Hostage to History: Cyprus from the
Ottomans to Kissinger*

Blaming the Victims (edited with Edward Said)

James Callaghan: The Road to Number Ten
(with Peter Kellner)

Karl Marx and the Paris Commune

*The Monarchy: A Critique of Britain's
Favourite Fetish*

*Blood, Class and Nostalgia:
Anglo-American Ironies*

*For the Sake of Argument:
Essays and Minority Reports*

International Territory: The United Nations 1945–95
(photographs by Adam Bartos)

When the Borders Bleed: The Struggle of the Kurds
(photographs by Ed Kashi)

The Elgin Marbles

Should they be returned to Greece?

◆

CHRISTOPHER HITCHENS
with essays by Robert Browning and Graham Binns

VERSO
London · New York

This edition published by Verso 1997
First published by Chatto & Windus Ltd 1987
© Christopher Hitchens 1987, 1997
Reprinted 1998

'The Parthenon in History'
© Robert Browning 1987

'Restoration and the New Museum'
© Graham Binns 1997

Verso
UK: 6 Meard Street, London W1V 3HR
USA: 180 Varick Street, New York NY 10014-4606

Verso is the imprint of New Left Books

ISBN 1 85984 220 8

British Library Cataloguing in Publication Data
A catalogue record for this book is available from the British Library

Library of Congress Cataloging-in-Publication Data
A catalog record for this book is available from the Library of Congress

Typeset by SetSystems Ltd, Saffron Walden, Essex
Printed by Biddles Ltd, Guildford and King's Lynn

Contents

Foreword to the 1997 Edition
Christopher Hitchens

Those who support the status quo at the British Museum, and the retention in London of a <u>great single work</u> of classical Greek sculpture, have the great advantage of inertia on their side. Their arguments need not be good; indeed they need deploy no actual arguments at all. Thus, one may patiently point out that the sculpture is mutilated by its enforced separation, that this is a highly unusual not to say unique situation, and that there exists no court or body that can enforce any 'precedent' in any case, and *still* be met by the jeering retort that return of the Parthenon marbles will empty not just the British Museum but all British museums.

Still, all efforts to shift the apparently immovable (in this case, the certainty of its own rectitude on the part of a section of the British Establishment) have had their moments of discouragement. It was depressing, admittedly, to read the exchange in the House of Lords on 19 May 1997, when a proposal for restitution was made by the doughty Lord Jenkins of Putney, and met with the following objections by other Noble Lords, as minuted in *Hansard*:

> Lord Boyd-Carpenter: My Lords, will the Minister bear in mind that the survival of these lovely creations results from their being taken over by this country and that it is therefore very important that they should remain here? *Credited with their survival*

> Lord Strabolgi: My Lords, is my noble friend aware that such a move would be an unwelcome precedent? If we started to return works of art to other countries, there would not be much left in our museums and galleries. *empty holders*

> Lord Wyatt of Weeford: My Lords, is the Minister aware that it would be dangerous to return the marbles to Athens because they were under attack *dangerous to return*

by Turkish and Greek fire in the Parthenon when they were rescued and the volatile Greeks might easily start hurling bombs around again?

All of these 'arguments' were offered *as if for the very first time*. And Lord Lucas was present, in order to make sure that the whiskery joke about 'losing our marbles' was not omitted from the record. This little book – which does no more than summarise a case built up over almost two centuries – was first published nearly a decade ago. A copy may be found in the excellent House of Lords library. If Lord Boyd-Carpenter was sincere about his concern for the survival of antiquities, and wished moreover to be clear about his history, he could have tidied up his confusion by consulting pages 24–36. The same can be said, I hope without undue immodesty, for the non sequitur that exercises Lord Strabolgi (pp. 83–7) and even for the alarmist views evinced by Lord Wyatt of Weeford (pp. 52–3) though I doubt, considering that bombs go off in London more, and more often, than in Athens, that anything can hope to change that mind. And are there that many Lords or Commons who really take the view that, having saved the property of a neighbour in an emergency, one would be justified in annexing it for oneself?

Let us not be too discouraged. In the same period, the descriptive term employed by the government and by more and more commentators has become the 'Parthenon sculptures'. Only the British Museum, bound as it is by the terms of a restrictive agreement, insists on the misleading term 'Elgin marbles' (see pp. 17 and 43). Alas, the incoming 1997 Labour government made a hasty commitment, in reply to a too-hasty question, to the dubious notion of the sculptures as 'an integral part' of the Museum. But even the term 'integral part' is an advance. If integrity is a consideration, then how much more are the two halves of the Parthenon frieze integral to each other? In subtle but important ways, the locus of debate on this question has shifted to a more elevated plane.

Public opinion, often supposed to be in populist thrall to the saloon-bar, dog-in-the-manger argument of 'where will it all end?', has shown more open-mindedness and generosity than some of the possessing classes themselves. After a remarkably comprehensive television presentation of the issues, conducted by William G. Stewart and transmitted by Channel Four in its *Without Walls* series on 16 April 1996, viewers were encouraged to register a vote by telephone. Those responding were not of course a 'scientific' sample (supposing there to be such a

thing) but of the 99,340 audience members expressing an opinion, no fewer than 91,822 – or 92.5 per cent of the total – cast their votes for restitution. At about the same time, one hundred and nine Members of Parliament, including ten who later became members of the Blair ministry, signed an Early Day Motion to the same effect.

It deserves to be said that the 'proposal' put to the Channel Four audience included three conditions to be met by the Greek side, *viz*: there should be a new Acropolis Museum ready to receive the sculptures; the costs of return, and of making a complete set of copies for exhibition in Bloomsbury, should be met by Greece; the Greek government should undertake to press no further claims for restitution. All of these conditions already have been or are being met by the Greek authorities – further proof that there is no objection, genuine or frivolous, to this obviously just solution that cannot easily be overcome.

The retentionists may sometimes inquire of themselves why it is that this argument, which to them appears so simple, keeps on coming up. For generations, large numbers of British people have agitated for the righting of a wrong and the repair, as far as may be possible, of a major aesthetic blemish. Though the historical record, in my view, offers conclusive support for the restitutionist position, it is the aesthetic argument which is unanswerable, and the 'bad precedent' argument which most needs putting out of its misery. To hear some people utter, one might suppose that the Parthenon sculptures would disappear from view if they were returned to Greece. While all unawares, it sometimes seems, the British government and people are being offered (at no cost to themselves, if that matters) the opportunity to perform a noble and even beautiful act. The Stone of Scone is a boulder, which can be revered on any site but no doubt is seen and experienced to better advantage in Scotland. Its significance is principally national, and there is no shame in that. The Rosetta Stone belongs to humanity, in that it helped the world to decode a script that is no longer in Egyptian usage, and is as well off in the British Museum as it would be in the Louvre or, if chance had so dictated, in the national museum in Cairo. The Parthenon sculpture is like a marvellous canvas arbitrarily torn across, with its depth and perspective and proportion summarily abolished. This is why, however long the debate should last, there will always be those who rebel against the disfigurement and who long to see it undone.

It is not so difficult to picture the actual scene. At a dignified

the Parthenon frieze is integral to the architecture

ceremony for the inauguration of the new Acropolis Museum, the caryatid sisters are reunited and the other sculptures put in harmonious configuration with one another. The Speaker of the Greek Parliament welcomes the Speaker of the British Parliament, or perhaps the Prime Minister, and solemnly thanks him for Britain's careful stewardship of the treasure, and the decency involved in returning it. In towns and villages all over Greece, and in Greek tavernas all over the world, the spirit of *phylloxenia* prevails and no British guest is allowed to pay his or her bill. It is discovered that the sculptures have not vanished, and indeed are accessible to all and visible to even greater advantage. In the correspondence column of the London *Times*, letters appear wondering why, after all, nobody thought of this before. The sad pleasures of retention suddenly appear petty and negligible when contrasted to the broad and spacious thing.

There are many good points on the restitutionist side. A motion before the European Parliament, signed by 250 members, speaks eloquently for instance of the contribution that return might make to a 'European' atmosphere. But essentially, either one can visualise the moment evoked above, or one cannot.

If that moment comes to pass, and I am morally certain that it will, there will be a residue of sadness. Professor Robert Browning, who guided and inspired the British Committee for the Restitution of the Parthenon Marbles, died suddenly in January 1997. His was the finest possible balance between the heart and the head: between the claims of natural justice and the scrupulous weighing of evidence. He was deeply mourned across the whole universe of classical scholarship, but perhaps those of us who knew him in the first fourteen years of the Committee's untiring labour can claim a position in the first rank of the mourners. There is not a page of this text that does not bear the impress of his care and measure.

Who speaks for the British – the Wyatts of Weeford or the Brownings? More depends on the answer than might appear at first glance.

Foreword to the 1987 Edition
Christopher Hitchens

In late 1982 I asked Alexander Chancellor, then editor of the *Spectator*, if I might contribute an article about the Parthenon marbles. He agreed and the piece, which was entitled 'Give Them Back Their Marbles', appeared on 1 January 1983. It got a warmer response than I had expected, as well as some rebukes from other *Spectator* contributors, and I'm told that it helped to re-ignite the argument in Britain. This argument was soon to become even more animated as a consequence of the Greek government's formal request for restitution. A freshet of articles and editorials appeared, none of them omitting the simple pun about 'losing our marbles' that is so beloved of the British headline-writer.

My first thanks, then, are due to Alexander Chancellor. But for guiding and developing my interest, and for correcting some errors that I had made in my enthusiasm, I am truly indebted to Professor Robert Browning, Mrs Eleni Cubitt and Mr Peter Thompson. The British Committee for the Restitution of the Parthenon Marbles is the most literate, resourceful and patient campaigning body I have ever struck, and operates in the great tradition of British philanthropy and internationalism.

Those who helped and advised me in Athens are numerous. I must mention Bruce Clark, Jules Dassin, Constantine Kalligas, Edmund Keeley, George Livanos, Alexandros Mantis, Melina Mercouri and Nicoletta Valachou. A long conversation with Professor Walter Burkert at a weekend session hosted by the Ionic Centre in Chios helped me to clarify many uncertainties about the Greek tradition.

In the United States I received much help and advice, and some admonitions, from Karl E. Meyer, whose concern for the fair treatment

of antiquities is precisely equalled by his feeling for the integrity of museums and collections. George Livanos and Kenneth Egan of the American Hellenic Alliance kept me afloat with generous support at a time when I needed it most. George Vournas is the institutional memory of the Greek American community. Nicos Papaconstantinou and Achilleas Paparsenos of the Greek Embassy in Washington were more helpful and kindly in answering queries than duty required of them. Bruce Martin of the Library of Congress is a good and disinterested friend of all scholars and researchers, however amateur. In London, Allegra Huston was patient with me and impatient with the least slovenliness in the text – a rare and apposite combination.

A final note. The term 'philhellene' is often used patronisingly in the English vernacular, as if it signified some slightly questionable Romantic addiction. I have been very impressed in the course of preparing this little book by the number of British people who, all down the generations since the marbles were removed, have looked at the matter in a sober and phlegmatic way and concluded that a wrong has been done. In a mostly dispassionate manner they have sought for nearly two centuries to put it right, while much of the emotional flailing has been done by those who deny that there is any problem in the first place. I do not think that emotions should always be distrusted, so I hope that the ensuing pages are true to those who have insisted that the emotions of others matter as well. The prompting of justice, like the voice of reason, is quiet but very persistent.

The author and publishers would like to acknowledge with thanks the following copyright holders:

Professor A. M. Snodgrass, Peter Levi and Professor A. A. Long from *The Greek World, Classical, Byzantine and Modern*, edited by Robert Browning, Thames & Hudson, London, 1985. Copyright © 1985 Thames & Hudson Ltd, London.

'Homage to the British Museum' by William Empson, from *Collected Poems*, copyright © The Estate of Sir William Empson 1955, 1984. Reproduced by permission of Lady Empson, Chatto & Windus, London, and Harcourt Brace Jovanovich, New York, © 1949, 1977.

R. E. Wycherly, *The Stones of Athens*, Princeton University Press, Princeton NJ, 1978. Copyright © 1978 by Princeton University Press.

F. M. Cornford, *Microcosmographia Academica*, Bowes & Bowes, Cambridge, 1908. Reprinted by permission of The Bodley Head, London.

C. M. Woodhouse, *The Philhellenes*, Hodder & Stoughton, London, 1969. Copyright © 1969 by C.M. Woodhouse.

Harold Nicolson, 'The Byron Curse Echoes Again', *New York Times Magazine*, 27 March 1949.

Luigi Beschi (contributor), Dr Helmut Kyrieleis (ed.) and Philip von Zabern (publisher) for the plan and other material reproduced in Appendix I, adapted from *Archaische Klassische und Griechische Plastik*, Mainz, 1986.

To the memory of Robert Browning
1914–1997

The Parthenon in History

Robert Browning

For close to two and a half millennia the Parthenon has stood on the
Acropolis, dominating the city of Athens. A few other buildings, such
as the pyramid of Cheops in Egypt, have endured longer. But none of
them displays the architectural complexity and the artistic distinction of
the Parthenon. And none possesses the rich associations and the symbolic
values which the Parthenon has acquired in the course of centuries. It is
no accident that when the United Nations Educational, Scientific and
Cultural Organisation (UNESCO) was established after World War II it
chose as its emblem the façade of the Parthenon. Nor was it by chance
that when in 1897 the citizens of Nashville, Tennessee, wished to build
in their Centennial Park a replica of a famous building, one which
would symbolise their own aspirations and recall the principles which
inspired the founders of the Union and those who saved it from
disintegration, they chose the Parthenon. Nothing, they believed,
would better represent the right to life, liberty, and the pursuit of
happiness, and government of the people by the people for the people.
Few of those who made that choice had ever seen the Parthenon, but
they knew what it was and what it meant.

A century earlier a similar project had met with less success. In the
years after Waterloo a proposal was made to erect a Scottish National
Monument on Calton Hill in Edinburgh. After some acrimonious
exchanges in the pages of the *Quarterly Review* and the *Edinburgh Review*
between the partisans of gothic and classical architecture, it was finally
decided to build a full-size replica of the Parthenon, sculptures and all,
which was to be both a Scottish Pantheon and 'a place of divine
worship'. An Enabling Act was passed by Parliament in July 1822, and
on 27 August the foundation stone was laid by the Duke of Hamilton

in the presence of King George IV. However, enthusiasm soon waned and money ran out. Only twelve columns of the west peristyle, with their cornice, were completed. They still stand, gaunt and forlorn, a mute witness to Scottish philhellenism and to Scottish caution, not to say parsimony.

A brief survey of the fortunes of the Parthenon since it was built, and of the role which it has played in the art, thought and feeling of succeeding generations, may add a historical dimension to the theme of the present book.

In 448 BC the Athenian assembly voted to employ its accumulated surplus revenue to rebuild the temple of the warrior-goddess Athena, which stood on the highest point of the Acropolis, dominating the city and its surrounding countryside. It was probably intended in the first place as a memorial to those who had fallen in the wars against Persia more than a generation earlier. The old temple of Athena had been begun just before or just after the battle of Marathon in 490 BC but had been razed to the ground by the Persians during their brief occupation of Athens in 480 BC.

But the decision to rebuild the ravaged monuments of the Acropolis was not mere brooding on the past. It was concerned with the present and the future too. Athens was now at the height of her political power. A treaty had been made with the Persians which guaranteed the Greek cities against outside interference and so fulfilled the purpose for which the Delian League, headed by Athens, had been founded after the Persian wars. Athens, however, was more than a locus of power. It was also the undisputed centre of an astounding intellectual and artistic awakening, which has marked the subsequent history of Europe and of the world. It was in fifth-century Greece, and above all in Athens, that men first reflected in a rigorous and yet imaginative way on the nature of knowledge, on the principles which guide human conduct, on the significance of their own past, on the way the universe was composed and how it worked. The very words logic, philosophy, ethics, history, physics are Greek. Athens was the first society which sought to solve the great problems of reconciling power with justice, social cohesion with individual freedom, and the pursuit of excellence with equality of opportunity. Politics and democracy are Greek words too. When work on the Parthenon began Aeschylus was recently dead, Sophocles and Euripides were at the height of their powers – the *Antigone* was produced as the foundations were being laid, the *Medea* a year after the

temple was completed. Socrates as a young man watched the Parthenon rise, and very probably took part in its construction, since he was a stonemason and sculptor by trade. Polygnotus, whom Theophrastus called 'the inventor of painting', painted his great fresco of the capture of Troy in the Stoa Poikile, overlooking the Agora in Athens, shortly before work began on the Parthenon. The new temple was to be the visible token and embodiment of the confidence and pride with which the generation of Pericles faced the world, and an inspiration to others, present and future. Like the great funeral oration which the historian Thucydides put in the mouth of Pericles, it was to be an everlasting monument to a unique and dazzling society.

Work was begun on the new building in 447 BC, and it was completed in 432 BC. We do not know much about the detailed arrangements for its construction. The moving spirits were Pericles, re-elected year after year to political leadership, and Phidias the sculptor, who had recently made the colossal statue of Athena Promachos which stood at the entrance to the Acropolis, and who was soon to work on the temple of Zeus at Olympia. He seems to have been the artistic director of the whole Periclean building programme. The principal architect was Iktinos, who had earlier designed the temple of Apollo at Bassae in Arcadia. 'In some sense,' writes Wycherly, 'the Parthenon must have been the work of a committee. In a very real sense it was the work of the whole Athenian people, not merely because hundreds of them had a hand in building it, but because the assembly was ultimately responsible, confirmed appointments, and sanctioned and scrutinised the expenditure of every drachma.'

Pericles' political opponents were, or pretended to be, indignant at the public expenditure involved and the raids made on funds originally contributed by Athens's allies for defence against the Persians. Pericles, they said, 'was decking out our city like a wanton woman, decorating her with costly stones and thousand-talent temples'. The opposition received little support. Pericles was re-elected again and again by his fellow citizens.

The Parthenon is a Doric peripteral amphiprostyle temple, that is, it has a row of Doric columns on either side and a double row in the porches at either end. It is built entirely of white Pentelic marble from Attica. The dimensions of the stylobate, or platform, are 69.51 metres by 30.86 metres (a proportion of 9 to 4, which recurs in other features of the building). There were originally fifty-eight columns, seventeen

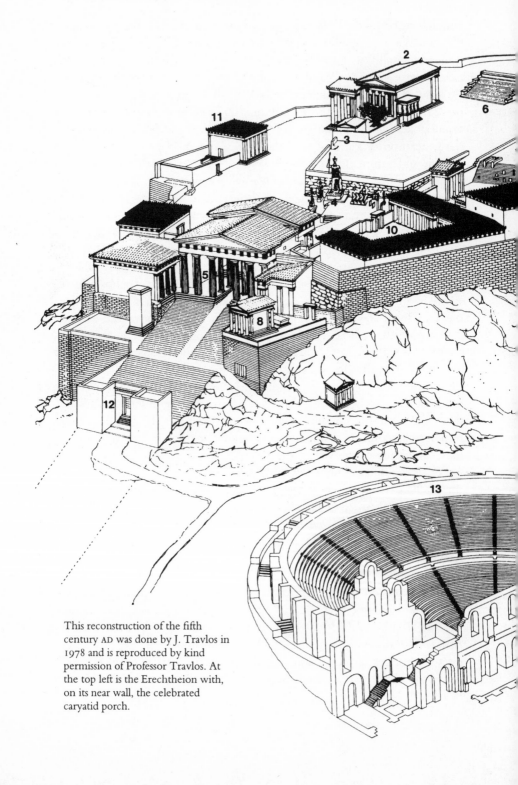

This reconstruction of the fifth century AD was done by J. Travlos in 1978 and is reproduced by kind permission of Professor Travlos. At the top left is the Erechtheion with, on its near wall, the celebrated caryatid porch.

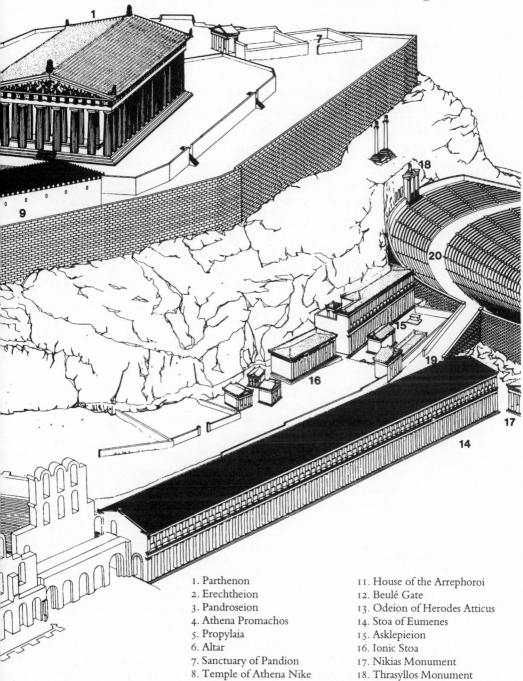

1. Parthenon
2. Erechtheion
3. Pandroseion
4. Athena Promachos
5. Propylaia
6. Altar
7. Sanctuary of Pandion
8. Temple of Athena Nike
9. Chalkotheke
10. Sanctuary of Artemis Brauronia
11. House of the Arrephoroi
12. Beulé Gate
13. Odeion of Herodes Atticus
14. Stoa of Eumenes
15. Asklepieion
16. Ionic Stoa
17. Nikias Monument
18. Thrasyllos Monument
19. Peripatos
20. Theatre of Dionysos

on either side, eight at either end, and six in the inner row in each porch. There was also an interior colonnade supporting the roof, of which a few traces still remain. The temple was divided into two chambers, the cella on the east, in which stood Phidias' gold and ivory statue of Athena, 12 metres high, and the opisthodomos on the west, in which the treasures of the goddess and the city were stored. There was no internal communication between the two chambers. The sculptures comprised triangular pediments at either end, with statues in the round representing the birth of Athena and her contest with Poseidon for the land of Attica, ninety-two metopes in high relief (thirty-two on each side, fourteen on each end) showing scenes from Greek mythology and legend of special Athenian interest, and a frieze in low relief 160 metres long depicting the procession to the temple at the Panathenaic festival. Metopes and frieze were part of the structure of the building and not decoration added after its completion.

'The Parthenon', writes Wycherly, 'is the culmination of Greek architecture.' The subtle refinements which exploit the distortions of human vision have only recently been fully observed and understood. It is also the culmination of Greek sculpture, far surpassing in both the quality and the quantity of its decoration any other building of the classical age. Building and sculpture were conceived and executed as part of a common plan. The importance of the Parthenon as a pan-Hellenic and not merely as an Athenian monument was recognised by Alexander the Great, who after his victory over the Persians by the river Granicus had twenty Persian shields suspended as votive offerings beneath the pediments of the temple.

The builders of the Parthenon built well. Little damage was done over the centuries by seismic activity, military operations or weather. However, a fire in the second century BC destroyed or damaged much of the interior, including the interior colonnade, the ceiling and the cult statue. The temple was restored, with a new statue modelled on the original, in 165–160 BC, probably by King Antiochus of Syria, in whose eyes the Parthenon was evidently a monument of more than local significance. Three centuries later Plutarch found in the sculptures both an aura of antiquity and the immediacy and freshness of youth, while for Pausanias, around 200 AD, the Parthenon was one of the 'sights' of Athens. In 362–363 the emperor Julian undertook extensive repairs as part of his campaign to re-establish pagan religion in an ever more Christian world. He had spent some time in

Athens as a student, and knew and loved the city and its venerable monuments.

Some time in the fifth century AD, probably in the reign of Theodosius II (408–450), the Parthenon was closed by order of the government in Constantinople. Proclus, the head of the Academy and one of the last great Neo-Platonist philosophers, lamented that he could no longer enter the temple to pray. Shortly afterwards it was converted, like many other pagan temples, into a Christian church, dedicated to the Holy Wisdom. This involved considerable adaptation. An apse was built at the east end, incorporating two of the prostyle columns and blocking the entrance to the cella. The building could now be entered only through the opisthodomos, which served as the narthex or porch of the church. Three doorways were cut through the wall between the opisthodomos and the cella. In this way the orientation of the building was reversed to accord with Christian usage. The floor was raised at the east end to form a chancel, upon which was set an altar surmounted by a baldachino supported by four porphyry columns. Round the inside of the apse ran a semicircular synthronon or raised bench for the clergy, with a marble throne for the bishop in the middle (perhaps that now in the storeroom of the Acropolis Museum). Whether there ever was a women's gallery is uncertain. The roof, which may have been in poor repair, was raised along the central axis of the building, and clerestory windows were set between the new and the old roof sections to provide internal illumination. The occasional, apparently deliberate, defacement of sculptured figures was probably the work of over-zealous Christians at this time; but there was no systematic defacement.

The interior of the new church may well have been decorated with mosaics and/or paintings, either directly on the marble of the walls or in fresco on a layer of plaster. There are faint traces of painting on parts of the walls. But virtually nothing is known of the early Christian decoration, which in any case may have been removed or plastered over during the prevalence of iconoclasm in the eighth and early ninth centuries.

The Parthenon continued in use as a Christian church for a thousand years. During this long period minor modifications and repairs were carried out. Some burials took place within or immediately adjacent to the building, probably in the early period of Christian use. From 694 until 1204 notices of the deaths of the bishops and archbishops of

Athens were carved high up on some of the peristyle columns. In 1018 the emperor Basil 11 came to Athens to give thanks for his victory over the Bulgars – and perhaps to seek forgiveness for his savage treatment of his prisoners. He made many valuable gifts to the church of the Holy Wisdom. A celebrated mosaic of the Virgin in the apse dates from the early eleventh century, and may well have been executed under the patronage of Basil. A reproduction of it figures on the seals of the archbishops of Athens from the eleventh century on. The mosaic itself seems to have been severely damaged by Frankish soldiers in 1204; no doubt they believed its gilt glass cubes were gold. Towards the end of the twelfth century the archbishop Michael Choniates 'beautified' – the word is his own – the church, of which he was fiercely proud. The mural paintings of which faint traces were still visible early in the twentieth century were perhaps part of his 'beautification'. An icon in the church was believed to have been painted by Saint Luke. An Icelandic pilgrim in the early twelfth century describes a miraculous lamp set before the altar which burned constantly without refilling.

In 1204, as a result of the Fourth Crusade, Athens passed into the hands of the first of a series of western rulers, the Burgundian de la Roches. The Parthenon was taken over by Latin clergy with a French bishop at their head, and became the church of Our Lady of Athens. They made little change in the appearance of the building. We hear of restoration of silver plates on the doors which had been removed in the mid-fourteenth century to pay Navarrese mercenary soldiers. A small tower was added over the west front. Some scholars believe that this tower was in fact built before 1204. But the Latins, if they did not build the lower square section, certainly added an upper cylindrical section. The new rulers were not entirely insensitive to the beauty of what they had inherited from antiquity. King Pedro IV of Aragon, then titular Duke of Athens, in 1380 described the Acropolis, of which the Parthenon is the most notable monument, as 'the richest jewel in the world, of which every king in Christendom would be envious'. It was in the last days of Latin rule that the first western classical archaeologist, Cyriac of Ancona, twice visited the Parthenon, in 1436 and 1447. He knew something of its origin and history. In his notebooks and letters he provides brief but ecstatic descriptions of the temple, accompanied by somewhat impressionistic drawings.

In 1458 the Frankish garrison on the Acropolis surrendered to the Ottoman Turks. Shortly afterwards Sultan Mehmed II, the conqueror

of Constantinople, visited Athens and expressed his admiration of its ancient monuments. During the period of Turkish rule, the Acropolis was a fortress occupied by Turkish troops and not easily accessible to visitors. The Parthenon became a mosque for the use of the garrison. Its mosaics and frescoes were whitewashed or plastered over. The Turkish traveller Evliya Chelebi (*c.* 1667) provides the only reliable and detailed account of the interior of the building at this period. 'We have seen mosques all over the world,' he writes, 'but its peer we have not seen.' Both the baldachino on its porphyry columns and the marble bishop's throne – which Evliya believed to be the throne of Plato – were still in place and undamaged.

The earliest descriptions of Athens by post-Renaissance western visitors belong to the period of Turkish occupation. In particular, the drawings of the Acropolis and its buildings made in 1674 for Louis XIV's ambassador, the Marquis de Nointel, show the exterior of the Parthenon and its sculptures in faithful detail. They were once attributed to Jacques Carrey of Troyes, and are often referred to as the Carrey drawings, though it is now certain that they are the work of an anonymous artist. The descriptions and illustrations by the French doctor and antiquarian Jacques Spon of Lyons and his travelling companion the English botanist George Wheler, who visited Athens in 1676 with a letter of recommendation from the Marquis de Nointel, are of particular interest, since they were allowed to enter the Parthenon. Their account of their travels in Greece was published in Lyons in 1678 in three richly illustrated folio volumes; 178 pages of the second volume are devoted to Athens.

In 1687 a Venetian army, made up almost entirely of mercenaries, besieged Athens in a vain attempt to drive the Turks from Greece. On 26 September, during a bombardment of the Acropolis by the Swedish Count Koenigsmark, a mortar bomb penetrated the roof of the Parthenon and caused the supplies of gunpowder which the Turks had stored in the building to explode. A few days later the city surrendered to the Venetians. The damage done to the Parthenon was extensive. The middle portions of the long side colonnades and the columns of the east porch were brought down; the upper part of the cella walls was largely destroyed; the interior colonnade was overthrown. During the two years of Venetian occupation further damage was caused by the removal of sculptures. The Venetian commander Francesco Morosini, eager to emulate Doge Enrico Dandolo, who in 1204 had brought from

Constantinople the four bronze horses now adorning the façade of the basilica of San Marco, tried to bring down the sculptures of the west pediment of the Parthenon. Their weight was too great for the equipment at the disposal of his engineers, and he succeeded only in smashing most of them. Two small pieces now in Copenhagen were picked up by a Danish officer in the Venetian service. A head of a Lapith found buried in the mud at Piraeus in 1870 was probably accidentally dropped overboard by a member of Morosini's army.

In the late eighteenth century the Comte de Choiseul-Gouffier, French ambassador to Turkey, acquired a piece of the east frieze and a metope from the south side of the building, as well as other fragments of lesser importance; these were probably detached by the explosion of 1687 and were lying on the ground. His efforts to obtain by bribery of officials more substantial specimens of the Parthenon sculptures met with failure. This did not diminish his enthusiasm for classical Greek art, and in 1790 he suggested to the Polish Diet that a replica of the Parthenon be erected in Warsaw to celebrate the new Polish constitution. The English traveller J. R. S. Morritt tried to buy one of the metopes in 1795, but found the Turks unwilling to sell anything. He observed that fifteen metopes were still in place on the south side of the building and in a good state of preservation.

The Parthenon could no longer serve as a mosque after the Venetian bombardment. But some time between 1689 and 1755 a small mosque was built without any foundations inside the cella walls. It was not finally demolished until a large part of it collapsed in 1842.

In 1799 Thomas Bruce, seventh Earl of Elgin, was appointed British ambassador to the Ottoman government. A detailed account of his activities in Athens is given elsewhere in this book. A summary will suffice here. His original intentions seem to have been unclear – drawing and modelling the Parthenon sculptures, or removing specimens of them whether they had already fallen to the ground or were still in place on the building. He found himself in a position of unexampled opportunity, since after the defeat of the French fleet by Lord Nelson in the battle of the Nile in August 1798 the Sultan looked to Britain to protect the Ottoman Empire against the French. As a result Elgin was able to obtain a *firman* from the Sultan's ministers authorising him to make casts and drawings of the sculptures in place on 'the temple of the idols', to excavate around the building for fragments, and to remove 'some pieces of stone with inscriptions or figures'. A former

Keeper of Greek and Roman Antiquities in the British Museum suggested that it is doubtful if this *firman* authorised Elgin to demolish any part of the structure of the Parthenon to obtain sculptures. Armed with this astonishingly vague document, however, he removed and sent to England fifty slabs and two half-slabs of the frieze and fifteen metopes – all that he considered worth taking, as he says. In the course of this he caused serious damage to the building by sawing through the frieze slabs, removing the cornice in order to detach the metopes, breaking the entablature on which they rested, removing marble slabs from the pavement, etc. In a later statement Elgin declared that it was only when he came to Athens and saw the danger that threatened the sculptures that he decided to remove them to ensure their preservation. But in fact his men were removing sculptures and packing them for despatch six months before his first and only visit to Athens in early summer 1802. His unprecedented privileges seem to have gradually led him morally and aesthetically out of his depth. As related elsewhere in this book, new evidence has recently cast doubt on whether the original *firman* was properly issued. Be that as it may, the end result was that the Parthenon was despoiled of the greater part of its sculptured decoration. The marbles were sold by Elgin in 1816 to the British government after a Parliamentary Committee had recommended their purchase, and then presented by the government to the British Museum.

During the Greek War of Independence the Acropolis was twice besieged, by the Greeks in 1821–22, and by the Turks in 1826–27. Superficial damage was caused to the buildings during both sieges. The Greeks were aware of their dilemma. Colonel Voutier, a French philhellene who commanded a battery of Greek artillery during the first siege, had qualms about destroying the monuments; and in 1822 John Coletis, Minister for War in the Greek revolutionary government, wrote to him asking him to try to preserve the antiquities and in particular the Parthenon. In the meantime the Turkish garrison of the Acropolis began to break the surviving walls of the cella to get at the lead shielding of the clamps and melt it down for bullets. The Greek besiegers sent a message offering to give them bullets if they would leave the Parthenon undamaged.

For three years from 1824 to 1826 the Parthenon housed a school for Greek girls whose fathers were fighting in the War of Independence. After the Turks recaptured the Acropolis in 1827 they remained in occupation until 1833, when they handed over to a Bavarian garrison.

It was not until 18 March 1835 that the Acropolis came under the jurisdiction of the newly formed Greek Archaeological Service, which has been responsible for all conservation, excavation and restoration since then.

When the Archaeological Service took it over, the Parthenon was in a sorry state. Yet its importance was universally recognised. In 1837 the Greek Archaeological Society was founded, and its first meeting was held in the ruins of the Parthenon. It was on that occasion that Iakovos Rizos Neroulos, the first president of the society, pointed to the crumbling buildings and the heaps of masonry and said, 'These stones are more precious than rubies or agates. It is to these stones that we owe our rebirth as a nation.' The Parthenon has been and is for almost all Greeks the symbol *par excellence* of their national identity, of their links with the past, and of the contribution that they and their forefathers have made to the civilisation in which we all share.

The first tasks that faced the Archaeological Service were the dismantling of the medieval and modern buildings that cluttered the Acropolis (this was sometimes done with more enthusiasm than discretion, in accordance with the archaeological practice of the time) and the identification of fallen portions of ancient structures. Then further excavation, repair and strengthening of the monuments, and the restoration of fallen or misplaced stones to their former positions (anastylosis). This work has gone on without interruption to the present day. A by-product of it was the creation of the Acropolis Museum, where all material from sites on the Acropolis is stored and displayed.

In 1894 an earthquake shook the Acropolis and caused much public concern for the safety of the ancient monuments. A thorough and long-term programme of repair and maintenance was drawn up, which was not completed till the 1930s. Many small fragments of structure and decoration were discovered and identified. Numerous cracks and displacements in the fabric of the Parthenon were repaired and further anastylosis carried out. Unfortunately many of the repairs then executed made use of iron clamps, as the technology of the time recommended. The subsequent rusting and swelling of those clamps has caused many problems. It is worth noting that the original builders of the Parthenon wrapped their iron clamps in lead to prevent rusting.

These problems were aggravated by the atmospheric pollution which accompanied increasing industrialisation and affluence. A report by

UNESCO experts in 1971 emphasised the urgency of a radical programme of conservation. In 1975, after the restoration of democracy in Greece, a planning committee was set up by the then Minister of Culture, Professor Constantine Trypanis. Its first task was to establish the facts. In 1977 the planning committee was expanded and became a permanent Committee for the Preservation of the Monuments of the Acropolis. The committee drew on the advice and help of archaeologists, architects, engineers, chemists and others in many countries in formulating a long-term programme based on the most advanced technology. The details of this programme, which will take many years to complete, are discussed elsewhere in this book by Graham Binns. Here I would like only to emphasise the quality of the care which is being given to the rock of the Acropolis itself, to its monuments, and to the Parthenon in particular. Greece is not a rich country, and it has more than its share of antiquities. But no expense and no effort is being spared to stabilise, conserve, and where possible to restore the greatest masterpiece of Greek architecture and sculpture – in the words of A. W. Lawrence, 'the one building in the world which may be assessed as absolutely right'. Throughout the work of restoration and conservation, the principle is being observed that nothing must be done which cannot be undone without damage.

The Parthenon was built by Greeks and belongs to Greece. But it also, in a sense, belongs to the whole world. The world may rest assured that it is in good hands. Those who had the good fortune to see the exhibition of conservation, restoration and research on the Acropolis, which was shown in Athens, Moscow, London and Amsterdam between September 1983 and January 1986, will have realised that the work now being carried out not only makes use of the latest results of scientific research, but also inspires those engaged in it to give their love as well as their skill. They know that they are the trustees for their people and for the whole world.

If the sculptures removed by Lord Elgin two hundred years ago can be returned to Athens, this will be a just and generous counterpart to the work of the Greek authorities and of the experts and craftsmen now working on the Acropolis. Whether any of them can or should be replaced in their original positions is a question for the technology and the taste of future generations. In the meantime they can be preserved and displayed in the new museum to be built at the foot of the Acropolis. It has recently been announced that the design of

this building will be the subject of a competition open to architects of all nations. It will thus be possible to see the whole of what remains of the Parthenon at the cost of a five-minute walk rather than a 1500-mile journey. The Parthenon has been there for a long time, and it will still be there long after the writer and the readers of these words have mouldered to dust and their very names are forgotten. The building and its sculptures were conceived and executed together. They will be better understood and appreciated if they can be seen together.

cannot divoe them

Suggestions for Further Reading

Many, though not all, of the topics of the present article are dealt with in two books:

B. F. Cook, *The Elgin Marbles*, London: British Museum Publications, 1984.

J. Baelen, *La Chronique du Parthénon*, Paris: Les Belles Lettres, 1956.

On the building of the Parthenon and its significance in the age of Pericles:

Susan Woodford, *The Parthenon*, Cambridge: Cambridge University Press, 1980.

J. Boardman, *The Parthenon and its Sculptures*, London: Thames & Hudson, 1985 (magnificently illustrated).

G. T. W. Hooker (ed.), *Parthenos and Parthenon*. Supplement to *Greece and Rome* 10 (1963). A collection of studies on the religious, political and cultural background.

R. E. Wycherly, *The Stones of Athens*, Princeton: Princeton University Press, 1978, ch. IV. A brief but perceptive study of the building and its sculptures and the political background to the construction of the temple.

E. Berger (ed.), *Parthenon-Kongress Basel*, 2 vols, Mainz: Von Zabern, 1984. Papers, mainly in English or German, delivered at a congress inaugurating the collection of casts of all the Parthenon sculptures in the Antikenmuseum, Basel.

On the significance of the Parthenon today:

David Lowenthal, *The Past is a Foreign Country*, Cambridge: Cambridge University Press, 1985.

On early western visitors to the Parthenon:

Fani-Maria Tsigakou, *The Rediscovery of Greece*, London: Thames & Hudson, 1981.

On Lord Elgin's acquisition of the Marbles:

Russell Chamberlin, *Loot*, London: Thames & Hudson, 1983.

A. H. Smith, 'Lord Elgin and his Collection', *Journal of Hellenic Studies* 36 (1916), pp. 163–372. A fully documented study of fundamental importance.

W. St Clair, *Lord Elgin and the Marbles*, Oxford: Clarendon Press, 1967 (reptd 1983). A narrative account set in a historical framework, and largely, though not exclusively, based on the material collected by A. H. Smith.

T. Vrettos, *A Shadow of Magnitude: The Acquisition of the Elgin Marbles*, New York: Putnam, 1974. A more critical account from a Greek standpoint.

On the Nashville replica of the Parthenon:

W. F. Creighton, *The Parthenon in Nashville*, Nashville: privately published, 1968.

On the Edinburgh Parthenon project:

G. Cleghorn, *Remarks on the Intended Restoration of the Parthenon as the National Monument of Scotland*, Edinburgh: privately published, 1824.

The Elgin Marbles

Christopher Hitchens

On a day in September 1802 a small group of Greeks, Turks and Englishmen assembled on the Acropolis. They had come to witness the removal of a metope from the structure of the Parthenon; a carved panel depicting a woman being borne off by a centaur. Present for the occasion were Edward Daniel Clarke, author of *Travels in Various Countries of Europe, Asia and Africa*, Giovanni Battista Lusieri, the Italian painter charged by Lord Elgin to oversee the removal of the sculpture to England, and the *Disdar*, an Ottoman Turkish official representing the occupying forces. As Clarke described the ensuing scene:

> After a short time spent in examining the several parts of the temple, one of the workmen came to inform Don Battista that they were then going to lower one of the metopes. We saw this fine piece of sculpture raised from its station between the triglyphs; but the workmen endeavouring to give it a position adapted to the projected line of descent, a part of the adjoining masonry was loosened by the machinery; and down came the fine masses of Pentelican marble, scattering their white fragments with thundering noise among the ruins . . .
>
> The *Disdar*, who beheld the mischief done to the building, took his pipe out of his mouth, dropped a tear, and in a supplicating tone of voice said to Lusieri, 'Τέλος' ['It is finished'].

Lusieri described the same moment in a letter to his master dated 16 September 1802:

> I have, my Lord, the pleasure of announcing to you the possession of the 8th metope, that one where there is the Centaur carrying off the woman. This piece has caused much trouble in all respects, and I have even been obliged to be a little barbarous.

This incident marks the beginning of the dispute over the Parthenon marbles. Most of the essential disagreements began even as Lord Elgin's men were at work. On one side was the human, immediate reaction to desecration. On the other, the satisfaction of a ticklish job well done. The first style is fervent, even emotional, whereas the second is euphemistic, emollient and phlegmatic. If Lusieri had not been the Italian and Clarke the Anglo-Saxon, caricatures of national sentiment would receive a strong reinforcement from the contrast.

But Lusieri was working for, and accountable to, Thomas Bruce, seventh Earl of Elgin and eleventh Earl of Kincardine. Under the terms of his acquisition of the statuary and sculpture, and under the terms of his disposal of it, Lord Elgin has made his own name indissoluble from the artefacts. To this day the British Museum is obliged by statute to refer to his collection as 'the Elgin Marbles'. This association between the collector and his collection is of some psychological importance. We laugh at 'Roman Polanski's *Macbeth*' and 'Ken Russell's *Mahler*', and lampoon them for the cultural *trompe-l'oeils* that they are. We grant Michelangelo's *Pietà* and Leonardo's *Mona Lisa*. But those who insist on 'the Elgin Marbles' are in some sense assuming what has to be proved.

The marbles have become a species of test case. If possession is not nine points of the law, how many is it, or should it be? Can we continue to justify an act — the amputation of sculpture from a temple — that would be execrated if committed today? And are there any standards, apart from national egoism or entrepreneurial reach, that should govern the apportionment of cultural property?

All these issues, which have recently been impressed on the British and to a lesser extent the Greek public, are as old as the separation of the marbles from the Parthenon and perhaps older. In the course of the argument there has been eloquent testimony from Lord Byron, Thomas Hardy, Nicos Kazantzakis, Constantine Cavafy, John Keats, George Seferis and many others. As the years have elapsed, also, considerable new evidence has become available to scholars.

The essential points, however, have always been perfectly intelligible to anyone with an eye for form or beauty. The argument would not be worth having if it merely involved the *amour propre* of governments, states and trustees. It may be worth, for a start, comparing and considering the two places which any student of the Greek style is compelled to visit.

Settings

1. The Acropolis

Philhellenes have been known to accentuate the superlative, but very few historians can be found to dispute the salience of fifth-century BC Athens. The Periclean age is a subject of widely differing interpretations. Some critics point to the imperialist and predatory character of the Athenians and others to the imperfections of their 'democracy'. But the immense achievements of the period are undeniable and do not owe any of their pre-eminence to myth. It is difficult to dissociate the period from the name of Pericles, as even his detractors obliquely concede. Educated by Damon, Zeno and Anaxagoras, he may have had a weakness for overseas adventures and he has been accused of pandering overmuch to the majority, but clearly he did not refuse to learn from his errors and defeats. He instituted an equitable social contract whereby – to the rage of his enemies – jurymen, soldiers and public servants were remunerated from the city treasury. The drama was subsidised and the standing of women slightly ameliorated. In return for this Pericles demanded a high standard of public spirit and called upon that sense of balance and symmetry which Thucydides immortalised in his funeral oration.

Here, ideally, the laws inspire rather than exact obedience; merit is the standard, and efficiency in military matters is not held to be antithetical to commerce or art. Pericles seems to have made some attempt to live his own precepts and to cultivate the idea of the whole man. A friend to Sophocles and Herodotus and a patron to Attic art, he (and his friend Phidias the sculptor) had to fight one great domestic battle against the 'practical, no-nonsense' men of his day.

About the year 450 BC Pericles proposed a decree to the Athenian assembly whereby money hitherto devoted to warring against Persia could be employed in the rebuilding of the temples and monuments destroyed in the second Persian war. Though a puritan outcry was raised against this proposal, it carried the assembly for reasons hinted at by Plutarch, who wrote in his *Pericles* that:

> The house and home contingent, no whit less than the sailors and sentinels and soldiers, might have a pretext for getting a beneficial share of the public wealth. The materials to be used were stone, bronze, ivory, gold, ebony

and cypress-wood; the arts which should elaborate and work up these materials were those of carpenter, moulder, bronze-smith, stone-cutter, dyer, veneerer in gold and ivory, painter, embroiderer, embosser, to say nothing of the forwarders and furnishers of the material . . . it came to pass that for every age almost, and every capacity, the city's great abundance was distributed and shared by such demands.

[margin annotation:] } c·t/craft

The centrepiece of the undertaking, a temple to Pallas Athena, thus called upon the skills and talents of every sector of the city. The name Phidias has come down to us as the Attic genius of sculpture, but he had immense resources at his disposal. So did the architect Iktinos, who was able to continue modifying his design as the work progressed. According to Professor J. M. Cook in his account of the Parthenon's construction, 'Practically every block in it is unique so as to fit the tilts and curvatures. Such extravagance could never be afforded again.' And, as he also puts it, 'the Parthenon style is the classical style *par excellence*. In the outcome, for better or worse, local styles of sculpture in Greece vanished. With artists now drilled in a common tradition, European art was set on a highway; and from Athens sculptors carried it beyond the limits of the Greek lands.'

In common with many great aesthetic innovations, the strength of this style lay as much in its purity and simplicity as in the loving detail and lavish decoration of its design. The *idea* is balance and symmetry, summed up in the triad of the metopes, the frieze and the pediments. No constituent of this edifice was new in itself, but the Parthenon raised each to a new level and to a new and more subtle relation with the others. The Parthenon had eight columns at the end instead of the usual six, and was able to accommodate a larger space for pedimental sculpture. Each of the ninety-two metopes is carved – an innovation for a building of this magnitude; and thus there is (or there was) a continuous frieze unique in Doric architecture.

The frieze, in low relief, and the metopes, in high relief, have afforded enormous scope for theorists of classical form and metaphor. The number of figures on the frieze is 192, which happens to be the exact number of the city's heroes who perished at Marathon. It may be argued that the procession represents the gods convened to greet them. Or the retinue may represent the Panathenaic procession, a votive occasion when Athens would have been *en fête* for its virgin goddess and patron. There is no reason, of course, why the frieze should not bear both interpretations.

As for the metopes, one can do no better than quote the slightly effusive reaction of the English painter Benjamin Robert Haydon, who first saw them in 1808 and was to become one of their greatest propagandists:

> The first thing I fixed my eyes on, was a wrist of a figure in one of the female groups, in which were visible, though in a feminine form, the radius and ulna. I was astonished, for I had never seen them hinted at in any female wrist in the antique. I darted my eye to the elbow, and saw the outer condyle visibly affecting the shape as in nature. I saw that the arm was in repose and the soft parts in relaxation . . . But when I turned to the Theseus, and saw that every form was altered by action or repose – when I saw that the two sides of his back varied, one side stretched from the shoulder blade being pulled forward, and the other side compressed from the shoulder blade being pushed close to the spine, as he rested on his elbow, with the belly flat because the bowels fell into the pelvis as he sat – and when, turning to the Ilyssus, I saw the belly protrude from the figure lying on its side – and again, when in the figure of the fighting metope I saw the muscle shown under the one armpit in that instantaneous action of darting out, and left out in the other armpits because not wanted – when I saw, in fact, the most heroic style of art, combined with all the essential details of actual life, the thing was done at once, and for ever.

Haydon would probably never have seen the marbles, or taken his friend John Keats to see them, if they had not been removed to London. (Let no one say that there have not been some excellent consequences of their separation.) The point is that more than two millennia after their creation the Parthenon sculptures had, and have, the power to evoke this sort of feeling. Clearly they could have this effect upon a person wholly ignorant of their provenance. But much of their fascination must also derive from their unchallengeable character as the *summa* of Periclean Athens. Is it even too romantic or too fanciful to view them as a partial embodiment of the Periclean ideal, with its injunction that 'each single one of our citizens, in all the manifold aspects of life, is able to show himself the rightful owner of his own person and to do this, moreover, with exceptional grace and exceptional versatility'? Ever since a large portion of the frieze and a significant number of the metopes were wrenched away from the parent building, there has been an aesthetic revulsion against the dismemberment.

In some part this derives from the common knowledge that balance, lightness and wholeness are the chief artistic legacy from the Athens of that time.

Since its original dedication to Athena, the Parthenon has undergone many indignities. It was closed and desolate in the fifth century after Christ. It became a Christian church under the Byzantines and was the site of the thanksgiving service held by the emperor Basil II in 1018 after his bloody revenge on the Bulgars. After the Turkish conquest in 1458 the Parthenon was transformed into a mosque and a minaret was added to its southwest corner. The Erechtheion became the commandant's harem.

The suzerainty of Christian Venice was perhaps the most ruinous of all. Under the command of Francesco Morosini, the Venetian forces laid siege to the Acropolis in September 1687 and one of their salvoes ignited a powder magazine which the Turks kept in the Parthenon. The resulting damage to the building was tragic and irreparable. Subsequent events did little to redeem Morosini's reputation; having employed stones from the ancient monuments to repair the city walls, he attempted to remove the central sculptures of the Parthenon's west pediment in order to take them home with him to Venice (an act which if successful would not, one hopes, have qualified him as a rescuer of antiquity even in the eyes of Venetian pamphleteers). His workmen were casual and callous; their clumsiness allowed the statues to fall and shatter, whereupon the shards were left where they lay.

Perhaps the most grotesque blasphemy to befall the Parthenon was in the present century. Although it was undamaged by the Nazi occupation of the city, the building was made to display a swastika flag as a symbol of Hitler's 'New Order' in Europe. I once had the privilege of shaking the hand of Manolis Glezos, who tore the offending emblem away on 31 May 1941, and thereby helped to ignite the Greek national resistance.

A pagan shrine, a church, a mosque, an arms dump, a monument to Nazi profanity and a target for promiscuous collectors of all kinds . . . It is a wonder that the Parthenon still stands. But none of its vicissitudes or mutilations has altered its essential character as the great surviving testimony of the Periclean age. This makes it precious to the Greeks, but also to human civilisation, however considered. Of the various depredations that the building has endured, only one can be put right – and that one imperfectly.

2. Bloomsbury

> In her sooty vitals, London stores these marble monuments of the gods, just
> as some unsmiling Puritan might store in the depths of his memory some past
> erotic moment, blissful and ecstatic sin. (Nicos Kazantzakis, *England*, 1939.)

There is probably no more Anglophile book written by a foreign visitor
than the travelogue composed by Nicos Kazantzakis on the eve of
World War II. His conclusion was that England had given humanity
the three great benisons of the Gentleman, Magna Carta and Shake-
speare. The Gentleman ('free, at ease, proud and gentle, brave and
modest, taciturn, self-controlled') speaks, as how could he not, for
himself. So, in their way, do Magna Carta and Shakespeare. Only in the
vaults of Bloomsbury did Kazantzakis allow himself any critical or
ungenerous reflections.

The Parthenon marbles consist of 115 panels of frieze, of which
ninety-four are still extant, either intact or broken, and of which thirty-
six are in the Acropolis Museum. Of the original ninety-two metopes,
thirty-nine are either on the temple or in the Acropolis Museum. One
panel of the frieze is in the Louvre. Of the surviving panels of frieze,
the British Museum holds fifty-six, and of the surviving metopes,
fifteen. Bloomsbury also has the care of seventeen pedimental figures,
including a caryatid and a column from the Erechtheion. In other
words, almost half of the surviving sculpture of the Parthenon is in
London and almost half is in Athens.

Since the sculptures were carved to adorn a building which still, with
some attenuation, survives, and since they were carved (most especially
the friezes) as a unity of action and representation, this state of affairs
seems absurd and would certainly be ridiculed if it were being proposed
today. Either all the marbles could be assembled in one museum in
London, or they could be marshalled in a museum in Athens next to
the Parthenon. But to keep them in two places, one of them quite
sundered from the Parthenon and its context, seems bizarre and
irrational as well as inartistic.

Since the British are not bizarre or irrational, and since they very
much resent the charge of philistinism, there must be another explan-
ation. It is most likely to be found in Bloomsbury, in the vast treasure-
house of the Museum itself.

In his poem 'Homage to the British Museum' William Empson caught some of the feeling of mingled awe and amusement that can be felt by a respectful but unsubmissive visitor to Great Russell Street:

> There is a Supreme God in the ethnological section;
> A hollow toad shape, faced with a blank shield.
> He needs his belly to include the Pantheon,
> Which is inserted from a hole behind.
> At the navel, at the points formally stressed, at the organs of sense,
> Lice glue themselves, dolls, local deities,
> His smooth wood creeps with all the creeds of the world.
> Attending there let us absorb the cultures of nations
> And dissolve into our judgement all their codes.
> Then, being clogged with a natural hesitation
> (People are continually asking one the way out),
> Let us stand here and admit that we have no road.
> Being everything, let us admit that is to be something,
> Or give ourselves the benefit of the doubt;
> Let us offer our pinch of dust all to this God,
> And grant his reign over the entire building.

Empson felt the weight of the British Museum; its sheer mass and the extraordinary self-confidence which it possesses. One is tempted to say that it might be more apt if, like its poor relation south of the river, the British Museum called itself the Imperial Museum. But let us offer our pinch of dust and admit that such thoughts are flippant and relativistic. History cannot be unmade. A visitor to the British Museum who knew nothing of the British would certainly be able to conclude that this was a people who had once enjoyed wide dominions. And so they did, as the possession of the Rosetta Stone, the treasures of Babylon and Egypt and countless other exhibits make plain. Well ordered and well displayed, the entire trove can be viewed in various ways (and Empson was not the only visitor to reflect that it was all, somehow, too much) but it cannot be derided. Here is the evidence of guardians who took, and take, their job very seriously indeed. This confidence and impassivity, which derive from generations of stewardship, will bear any interpretation of the word 'responsibility'. Against it, the gentle raillery of Kazantzakis and the vague impatience of Empson seem quite impotent. Yet Kazantzakis was right. There is, in one of the museum's priceless acquisitions, a repressed and guilty secret. It has taken a certain

time to come out, but this postponement has only enhanced the 'blissful and ecstatic' nature of the original sin.

The Acquisition: 1

The most complete account of Lord Elgin's adventure into Greece is also the most sympathetic. In 1916, the *Journal of Hellenic Studies* gave itself over to an immense and detailed article, 'Lord Elgin and his Collection', by Arthur Hamilton Smith, then Keeper of Greek and Roman Antiquities at the British Museum. Smith was a defender of Elgin in both a public and a private capacity. His concern as Keeper was with the integrity of the Museum, and he was a distant relation of the Elgin family. His exhaustive essay, nonetheless, is a model of objective and dispassionate scholarship. There is only one instance (rather a glaring one, as we shall see) in which partiality may have played a role. More impressive, from the standpoint of eight decades later, are the candour and accuracy with which Smith approaches his subject. Seldom can any chronicler have more doggedly followed the injunction to do the thing 'warts and all'.

The unintended effect of Smith's narrative is felt from the very first page. 'Lord Elgin, the subject of this paper, was educated at Harrow (where he stayed for a short time only) and at Westminster ... He entered the army in 1785, and without any active military service reached the rank of major general in 1835. He was elected a Representative Peer of Scotland in 1790 and continued in that position till 1807.' There follows a full-length plate of Elgin which would strike most observers as distinctly affected and over-posed. It is almost as if Smith wanted to summon a picture of the bored, spoiled lordling. Yet nothing could have been further from Smith's intention. Elgin emerges here as a man of considerable determination and address; prone on occasion to self-pity but zealous and cultivated.

His great vice was parsimony. Appointed, not without some lobbying on his own part, to the post of Ambassador to the Sublime Porte at Constantinople in the year 1799, he decided that his tenure would be remembered for its devotion to the fine arts. He conceived the pretty idea of making sketches and casts of the great ruins at Athens and solicited government support for the scheme. On all sides he heard good reports of J. M. W. Turner, who was then twenty-four and

beginning to win golden opinions. Turner was willing to undertake the commission but it proved impossible to secure him because, in Elgin's own words:

> He wished to retain a certain portion of his labour for his own use; he moreover asked between seven and eight hundred pounds of salary, independently of his expenses being paid, which of course was out of my reach altogether; therefore nothing was done here preparatory to the undertaking at all.

Elgin told this to the House of Commons Select Committee on the Marbles some seventeen years after the fact, forgetting, perhaps pardonably, that Turner had only asked £400. He had anyway missed the chance to engage a great artist on a great project – a patronage which by itself might have immortalised him. Smith writes, intriguingly, that 'It was quite natural that Lord Elgin, when in need of an artist, should think of Turner. Had he engaged him in place of Lusieri, it is probable that more drawings would have been completed *but it is certain that the Elgin collection of marbles would never have been made*' (italics mine). What made Smith so sure of this last assertion? His own narrative shows how, stage by stage and sometimes imperceptibly to its participants, a project devoted to culture and the fine arts became an enterprise, an undertaking and finally an opportunist acquisition.

Elgin's first step, after the decision to drop Turner, was to engage the services of two lesser men. William Richard Hamilton, a fellow Harrovian and later a trustee of the British Museum, was appointed his private secretary at the Constantinople embassy. And Giovanni Battista Lusieri, an illustrator down on his luck, was hired (at the salary, incidentally, of £500 a year) as *peintre en titre*. Lusieri's portfolio of Athenian paintings was lost at sea many years later and few of his other works survive, but he had a reputation as a meticulous draughtsman with a great capacity for pains but little flair for light or shade.

Hamilton was to rise to the eminence of Under-Secretary of State for Foreign Affairs and in that capacity, after Waterloo, to oversee the restitution of works of art purloined by Napoleon. In 1799, however, we find him writing to Elgin that:

> The French have taken away from Rome all the valuable Statues – Sixty-two choice pieces from the Vatican alone – among which are the Torso Apollo of Belvedere, Laocoön, Meleager, etc – besides the best from the other Museums – Most of the best pictures are also at Paris – During the

> Republic Chef-d'oeuvres of the first Masters were selling for nothing – and
> all the Galleries but that of Doria, have lost their best oil-paintings –
> Luckily the works in Fresco were immoveable.

Smith comments that it is 'interesting' to find Hamilton writing in this way. Others might prefer to see it as ironic.

As the eighteenth century turned into the nineteenth, Elgin's subordinates assembled a commission with the still-limited objective of taking casts, making sketches and otherwise representing the glories of Athenian antiquity. An artist from Astrakhan in Russia named Feodor Ivanovich and known to all his peers as 'Lord Elgin's Calmuck' was taken on in Rome. So were a pair of architectural specialists named Vincenzo Balestra and Sebastian Ittar, and two moulders of casts. In July of 1800 the advance guard of the party reached Athens and was greeted by the British consul, Spiridon Logotheti.

Logotheti stood in much the same relation to Elgin, who was by now established in Constantinople, as did Athens to the Ottoman capital. Greece in the declining days of Turkish rule was a miserable, abject country. British Foreign Office papers concerning Ottoman revenues describe Athens as 'the forty-third city of European Turkey'. It was run as a source of pelf for its two imperial overseers, the *Voivode* or governor, and the *Disdar* or military governor of the Acropolis. It was the *Disdar*'s privilege to exact tribute from visitors to the ruins – in 1785 Sir Richard Worsley described gaining admission at the cost of 'a few yards of broad-cloth to the wife of the *Disdar*'. Lord Elgin's draughtsmen were initially obliged to pay five guineas a day.

Since Athens was a village of perhaps twelve hundred houses, the grand structures of Greek and Roman antiquity had been pressed into service by the Turkish garrison. The Parthenon contained a mosque for their devotions, the Erechtheion had become a powder magazine and the pillars of the Propylaia provided convenient bricked-up emplacements for cannon. The Theseion was a church, while the Tower of the Winds did duty as a centre for the whirling dervish sect. The Christians were almost as casual as the Moslems – the Monument of Lysicrates serving as the storeroom for a French Capuchin convent. Every traveller of the period reported that slabs of Pentelic marble were used higgledy-piggledy to shore up hasty new structures.

Arriving on this scene in April 1801 and finding his party already at work, Lusieri wrote to Elgin that conditions were rather makeshift and

that 'everything that has been done up till now in the citadel has been by means of presents to the Disdar, who is the commandant'. Lusieri continued:

> He, however, has been threatened by the Cadi and Voivode if he should continue to admit us to the fortress, and has just told us that henceforth it was impossible to work there without a *firman*. I therefore beg your Excellency to have one sent to us as soon as possible, drawn up in such terms as to prevent us meeting with new difficulties in resuming and peaceably continuing our work.

This appeal for a *firman*, or signed authorisation by the Sublime Porte, was seconded by Elgin's friend Hunt and by Logotheti.

Up to this point, it is important to remember, Lord Elgin's declared plan was to do no more than make copies and representations, and perhaps collect a few scattered specimens. But, as he was later to tell the House of Commons, his whole design altered at some point in May 1801:

> From the period of Stuart's visit to Athens till the time I went to Turkey, a very great destruction had taken place. There was an old temple on the Ilissus had disappeared . . . every traveller coming, added to the general defacement of the statuary in his reach: there are now in London pieces broken off within our day. And the Turks have been continually defacing the heads; and in some instances they have actually reported to me, that they have pounded down the statues to convert them into mortar: It was upon these suggestions and with these feelings, that I proceeded to remove as much of the sculpture as I conveniently could; *it was no part of my original plan to bring away anything but my models* [italics mine].

Elgin's evidence here is not as unambiguous as he makes it sound. The application for a *firman* closes with the entreaty (as translated from Italian into English) that 'when they wish to take away some pieces of stone with old inscriptions or figures thereon, that no opposition be made thereto'. The final section of the *firman* itself, when rendered from the Italian, commands the subordinates of the Sublime Porte not to 'meddle with their scaffolding or implements, nor hinder them from taking away any pieces of stone with inscriptions or figures'.

There are a number of legal and linguistic inconsistencies in the firman which I have postponed to a later chapter. For the moment it is enough to notice what offends the Greeks so much. By Elgin's own account, and by all other certifiable histories, the Turks cared little or

nothing for the temples under their control and even desecrated them
to make mortar. What, then, is the moral force of a Turkish document
which gives to foreigners the right to make themselves free of the
Parthenon?

The actual force was one of *realpolitik* or *force majeure* or *raison d'état*
or what you will. In these departments Elgin held a definite advantage.
Lord Nelson's victories at the Nile had greatly impressed the Turks and
indebted them to their British allies in the struggle against Bonaparte.
As Elgin himself put it:

> In proportion with the change of affairs in our relations towards Turkey,
> the facilities of access were increased to me and to all English travellers; and
> about the middle of the summer of 1801 all difficulties were removed; we
> then had access for general purposes . . . The objection disappeared from
> the moment of the decided success of our arms in Egypt? Yes; the whole
> system of Turkish feeling met with a revolution, in the first place, from the
> invasion of the French, and afterwards by our conquest.

Without this uniquely favourable conjunction of circumstances,
which included the continued subjection of Greece to the Ottomans, it
is quite impossible to imagine Lord Elgin doing any more than taking a
few creditable casts and etchings back home with him. Bringing 'home'
in this case may mean more than repatriation. As Elgin wrote to Lusieri
on 10 July 1801:

> Balestra has with him several drawings of my house in Scotland, and some
> plans of the site on which it is intended to build here. As regards the latter,
> it would be necessary to me to have them by the first opportunity. The
> plans for my house in Scotland should be known to you. This building is a
> subject that occupies me greatly, and offers me the means of placing, in a
> useful, distinguished and agreeable way, the various things that you may
> perhaps be able to procure for me.
> The Hall is intended to be adorned with columns – the cellars
> underneath are vaulted expressly for this.
> Would it then be better to get some white columns worked in this
> country, in order to send them by sea to my house? Or to look out for
> some different kinds of marble that could be collected together in course of
> time and decorate the hall (in the manner of the great Church at Palermo)
> with columns all different one from another, and all of fine marble –
> supplementing them with agates and other rare marbles which are found in
> Sicily, and which are worked in small pieces?
> I am inclined towards the latter plan. If each column was different and

each beautiful, I should think that the effect would be admirable but perhaps better if there were two of each kind.

In either case I should wish to collect as much marble as possible. I have other places in my house which need it, and besides, one can easily multiply ornaments of beautiful marble without overdoing it; and nothing, truly, is so beautiful and also independent of changes of fashion.

These reflections only apply to unworked marble. You do not need any prompting from me to know the value that is attached to a sculptured marble, or historic piece.

Here, perhaps, in a private letter, one can detect the slight cupidity that was the counterpart of Elgin's parsimony. No mention, you will notice, is made of the cause of fine arts and civilisation. Indeed, in much of his less confidential correspondence Elgin only inserted such considerations as an afterthought. It was seriously suggested to him at one point by the Reverend Philip Hunt, his chaplain at Constantinople, that the entire caryatid porch of the Erechtheion be removed. 'If your Lordship would come here in a large Man of War that beautiful little model of ancient art might be transported wholly to England.' Elgin wrote at once to Lord Keith, naval commander-in-chief for the Mediterranean:

> I have been at monstrous expense at Athens [a city he had not yet even visited] where I at this moment possess advantages beyond belief . . . Now if you would allow a ship of war of size to convoy the Commissary's ship and stop a couple of days at Athens to get away a most valuable piece of architecture at my disposal there you could confer upon me the greatest obligation I could receive and do a very essential service to the Arts in England. *Bonaparte has not got such a thing from all his thefts in Italy.* Pray kindly attend to this my Lord [italics mine].

Lord Keith could not spare a ship of the line either for Lord Elgin's private gain or for the enhancement of 'the Arts in England' – two notions which seemed confused in the letter. Nor was he asked to rescue the marbles from the barbarous Turks – the idea that he was saving them had not yet occurred to Elgin. But the caryatid porch was put to the saw, as we shall see.

The Reverend Hunt seems to have been a most worldly chaplain. In a letter to Hamilton dated 8 July 1801 he spoke of the diplomatic mission with which he is entrusted, 'to create an impression in favour of our view and of our power . . . to repress the rebellious, and encourage the faithful and Loyal servants of the Porte'. He continued:

On such Classic ground investigation into the remains of Antiquity, and an attempt to procure such as are interesting and portable will naturally come in as a secondary object; and as I shall carry a Ferman to enable our Artists to prosecute without interruption their researches in the Acropolis of Athens, I will take care to see it put properly into execution. When as many of these objects *political and classical* are attained, as I find practicable, I hope to be able to proceed to Rhodes [italics in original].

A few weeks later, on 31 July 1801, the first metope was removed from the Parthenon. From that date onwards the practical side of things became uppermost. Lusieri wrote to Elgin on 30 September:

I hope that no further difficulties will be raised, as to continuing the diggings at the Temple of Minerva, and I shall be able to get possession of all the fragments I find. Mr Hunt wrote to your Excellency on my behalf to send a dozen marble saws of different sizes to Athens as quickly as possible. I should require three or four, twenty feet in length, to saw a great bas-relief [the centrepiece of the east frieze] that we could not transport unless we reduce its weight.

Elgin promised the saws but Lusieri could not wait. On 26 October he reported that:

with a single saw that I have got from the convent, they have sawn a precious fragment of the cornice of the Temple of Neptune Erechtheus [the Erechtheion] and with the same saw they are now sawing a bas-relief, a part of the frieze of the Parthenon.

This meant, as A. H. Smith non-commitally points out, 'the operation of cutting off the backs of the architectural sculptures, if their thickness made them inconveniently heavy . . .'

It may be worth noting what the Reverend Hunt was up to when he escorted the marbles and metopes by ship from Athens to Alexandria. Due to an unfavourable wind, as he noted in a letter to Elgin dated 8 January 1802,

We were therefore forced to put into a port of Asia near the ancient Halicarnassus; from whence I carried off a votive altar, with sculptured festoons and an Inscription. After Twenty days stay in that miserable deserted Port (during which time my Fever and Ague &c perpetually tormented me,) we reached [Capo Créo] the ancient Cnidus. There contrary winds gave me an opportunity to carry off some beautiful fragments of Ionic and Corinthian Cornices, Freezes &c but others which I was forced to leave from their bulk may be had on my return.

The words 'rescue' or 'preservation' do not occur here any more than they do in Elgin's letter to Lusieri of a few days previously. He advised him 'to excavate at Olympia. It is one of the most interesting and curious pieces of work – a place that has never been touched.'

Here, then, the excuse of Turkish depredation did not apply. Speaking in the same letter of the work at Athens, Elgin stipulated:

> I should wish to have, of the Acropolis, examples in the actual object of
> each thing, and architectural ornament – of each cornice, each frieze, each
> capital of the decorated ceilings, of the fluted columns – specimens of the
> different architectural orders, and of the variant forms of the orders – of
> metopes and the like, as much as possible. Finally, everything in the way of
> sculpture, medals and curious marbles that can be discovered by means of
> assiduous and indefatigable excavation. This excavation ought to be pushed
> on as much as possible be its success what it may.

It is useful and important to know the background to this note of urgency. Though one seldom finds an allusion to the fact in the vast correspondence of the collecting classes, it was an open secret that the Greeks did not love their Ottoman masters. The 1821 revolt was only a few years away and some murmurings could already be distinguished. Thomas Harrison, Lord Elgin's architect, put it rather bluntly when he wrote to his employer that 'the opportunity of the present good understanding between us and the Porte should not be lost, as it appears very uncertain, from the fluctuating state of Europe how long this part of Greece may remain under its present Master . . . Greece may be called maiden Ground.'

Harrison was on to something there, though one might question whether a country so ravished could be called 'maiden'. The collecting classes at any rate appear to have understood that their time of opportunity was not long. As Elgin wrote to Lusieri concerning the temples at Eleusis:

> The monuments never seem to have been taken, nor the site determined.
> It would be necessary to take a couple of saws for the finds. There is
> already a metope lying on the surface, with two torches crowned with an
> inscription, pretty much as follows ΧΑΙΟΙ. A little further is an *enormous*
> triglyph, good to measure, or to take [italics in original].

Members of Elgin's party and others employed this period to 'carry off' immense finds from Corinth, Eleusis, Mycenae and elsewhere. Today's Greeks do not request the return of anything but the sculptures

of the Parthenon. But then they are not told in the other cases that the removal was all for the good of Greece.

The sound of the saw was heard with increasing persistence as the year 1802 wore on. Lusieri wrote to Elgin, again concerning the centrepiece of the east frieze, that:

> Not being well-sawn, for want of sufficiently fine saws, and being a little weak in the middle it parted in two in course of transport, in spite of all the precautions taken. Happily it broke in the middle, in a straight line, at a place where there was no work, so that the accident has helped us to transport it quickly and put it on board.

And, concerning a Doric capital from the Propylaia:

> I will also take one from the Parthenon, but it is necessary to saw it in two. The Propylaea one is fairly large, but this is enormous. The gates of the citadel are not wide enough to let it pass. The three capitals, one Doric of early style, and two Corinthian, of a different date, and very early, which were in the old chapel near the Stadium, are in the store.

More significant, perhaps, given the late date (16 September 1802) was the concluding paragraph in which Lusieri counselled Elgin:

> I advise you, my Lord, to procure a firman for the Disdar, in which everything that he has done for your Excellency is approved. It is a paper that you promised him before you left Athens.

This *firman*, then, was to be retroactive, since the work which it was to license had already been carried out. Did Lusieri and Elgin suspect, or know, that they had exceeded even the ambivalent provisions of the original 1801 *firman?* Certainly the *Disdar*, who had had a few presents from his English friends (Elgin replied to Lusieri's letter that 'so long as he is my friend he will have solid proofs of my friendship'), seems to have felt that additional protection was required. Indeed, the practice of *ex post facto* justification became second nature to the whole Elgin–Lusieri expedition. Consider, for example, Elgin's *Memorandum* to the House of Commons Select Committee, in which he gave an affecting description of 'the house of the old Turk'. The old Turk in question confessed, 'laughingly' according to Elgin, that he had made mortar out of the marble statues of the Acropolis, whereupon, as the *Memorandum* expresses it:

Lord Elgin afterwards ascertained, on incontrovertible evidence, that these statues had been reduced into powder, and so used. Then, and then only, did he employ means to rescue what still remained from a similar fate.

But the story of the old Turk (which we have no reason to doubt) is given as occurring in May of 1802. And the first panels of the Parthenon were removed in July 1801 long before Elgin visited Athens at all. A committee deliberating in London more than a decade later would have had to be very acute and well-informed to notice the discrepancy, which occurs in Smith's narrative though he does not point it out.

By the end of his expedition Elgin had accumulated much of the best of what the Acropolis had to offer. Those who say that the buildings and sculptures are better for his exertions, no matter what his motive, must ask themselves whether he left the buildings and sculptures any better than he found them. Of the buildings, which had their entablatures rudely hewn away, one would have to answer no to this question. Of the sculptures, it is possible to argue that they might have been worse off if Elgin had never been born, or never appointed ambassador to a corrupt and declining imperial court. But the conditional mood is a tricky one. Consider the fate of the *Mentor*.

The *Mentor* was a small brig commanded by a Captain Eglen. It had been purchased by Lord Elgin, and left the Athenian outport of Piraeus on 5 January 1802 with many boxes of moulds and sculptures. There were three marble torsos from the Parthenon, a piece of the frieze and a marble throne aboard. Having taken the long route around Alexandria and Cyprus in order to ship more cargo, the *Mentor* sank in deep water off Kythera. The frieze of 'wingless Victory', in four boxes, was retrieved within a month but the remainder seemed beyond salvage. Elgin despatched a servant of Hamilton's, one Peter Gavallo, to contact the British consul at Kythera. To this official, Emmanuel Caluci, he bore a letter. In the letter Elgin wrote of the marbles on the sea bottom: 'The cases contain stones of no great value in themselves, but it is of very great consequence to me to salve them.'

Had these cases not survived and had they not, with enormous labour on the part of local fishermen, been retrieved, Lord Elgin's name would have been associated as much with the loss of treasures as with their acquisition, and his description of them − 'stones of no great value' − would have come down to us as another example of heroic British diffidence.

★

almost lost the ancient artifact

One day in February 1803 – no certain date can be ascribed – the vessel *Braakel* sailed from Athens. On board were, in the words of A. H. Smith:

> The principal statues of the East Pediment, viz, the Theseus, the Demeter and Kore, the Iris, the single Fate, and the pair of Fates; and from the West Pediment the Hermes and the Ilissos. There were also two metopes, seventeen cases of Parthenon frieze, seventeen inscriptions, the Dionysos from the monument of Thrasyllos, seven Egyptian pieces, parts of the cornice and architrave of the Erechtheum, the soffits of the Theseum, the four slabs from the frieze of Nike Apteros, which were the first objects to be saved from the *Mentor*, the two fragments supposed to be from Mycenae, the sundial of Phaedros, and many minor fragments.

On his own way home Lord Elgin had the misfortune to be interned by the Bonapartist authorities as a hostage for the safe return of the French general Boyer. He remained at Pau until released on parole by Talleyrand in 1806. This did not, however, prevent Lusieri from acting as if his master's orders were still extant. 'Everything', Elgin had once enjoined. Very well. Under the new British ambassador, Sir William Drummond, new acquisitions and shipments included one of the caryatids, the column from the eastern portico of the Erechtheion and numerous other reliefs, vases and fragments. Large pieces of the frieze remained to be had and Lusieri's letters show the difficulty he encountered. He continued to write doggedly and loyally, whether he received a reply or not. For one thing, there was need of a new *firman*. For another, the relevant Turkish official had been promised 'a watch and gold snuff-box' which had not arrived. Lusieri needed quinine, as he mentioned on more than one occasion. He also wanted relief from consul Logotheti, who was apparently becoming a bore:

> He is ill-regarded and has not the least influence on account of the bad conduct of all his children, and the folly of Nicolacci [his son]. Several English have even threatened to make him lose his vice-consulate, and sooner or later he will lose it. As your Excellency's affairs will be much better in my hands, I intend from henceforth to have nothing to do with the Greeks. I don't need them. I talk the language sufficiently, and shall begin directly to learn Turkish, to dispense with them.

The whole tone of the correspondence between Lusieri and his patron becomes increasingly querulous from then on. There is wearisome talk of a *firman* here and a bribe there, endless difficulties with

transport and communications and numerous accounts of pitiful local intrigues. There was also the cumbersome question of the town clock, a present from Lord Elgin to the people of Athens. Vast and piffling exchanges took place about the location of same and the question of who should defray the cost of the tower on which it was eventually placed. Lusieri continued to send vases and fragments even after he learned of the eventual success of Elgin in selling the Parthenon marbles to the British nation. These minor artefacts were used to embellish Elgin's home at Broomhall. But Elgin was tiring of his devoted friend and agent. In January 1819 he wrote to him, explaining:

> If it were possible, I should have nothing so much at heart as to continue to employ your talents on a theatre so worthy of them. But the injustice I have suffered with respect to this collection, many misfortunes that have come upon me, and a numerous family have so curtailed my means, that with real regret I submit to the necessity of bringing everything to a close that can cause expense.

Poor Lusieri, his powers of drawing were on the wane. He could offer only two finished pictures. In forwarding Lusieri's letter Hamilton wrote a pitiless covering note:

> I enclose a packet from Lusieri, which you should only read on a very fine day. It shows him an arrant Jew . . . His excuses for his idleness are abominable, and he evidently has finished nothing – nor indeed *done* anything *to the purpose*, in any way whatever, for the last four or five years [italics in original].

Elgin wrote back to Hamilton, justifying his treatment of Lusieri by claiming that he had outlived his usefulness. 'As long as he had on hand the collecting of the Sculpture, and making extensive excavations, extra charges came to be necessary, both for his personal aid and for the countenance of the Turkish authorities. But for many years, these occasions have ceased.'

On 19 February 1821 Lusieri wrote once more, 'again dwelling on the want of funds and of news'. It was a far cry from the brave days when in Lord Elgin's name he could suborn Turkish officialdom and even behave 'a little barbarously'. It was also his last letter. On 1 March 1821 he died. Had he lived a few more weeks he might have witnessed that month's outbreak of the Greek revolution against Ottoman rule. But then he had sworn 'henceforth to have nothing to do with the Greeks'.

His entire portfolio of drawings, the harvest of twenty years' work, was lost in the wreck of HMS *Cambrian* off Crete on 31 January 1828.

The Acquisition: 2

Elgin's 1819 letter cutting off Lusieri has a ring of self-pity. But the 'injustice' and the 'misfortunes' to which he alluded were by no means wholly imaginary. In his excellent book *The Plundered Past*, Karl Meyer writes that Lord Elgin's coveted appointment to Constantinople caused him to lose 'his fortune, his reputation, his wife and the lower half of his nose', For the last affliction, which resulted from a skin disorder he contracted in Turkey, Elgin was to be dogged by unfounded and unfeeling jokes about syphilis. His freedom from the status of hostage in Napoleonic France, which he endured for three years, was only purchased at the cost of a very restrictive parole from Talleyrand which ruined his diplomatic prospects. His vivacious wife, Mary, exploited his absence to live openly with another man, Robert Ferguson, who was a neighbour in Scotland. A painful divorce ensued.

But the unkindest cut, from Elgin's point of view, must have been the reception that was accorded to his trove of marble. The sculptures had continued to arrive in London while he was still a prisoner in France. On his return he arranged for their showing in an improvised shelter adjoining his temporary house on Park Lane. Their authenticity was promptly challenged by Richard Payne Knight, an opinionated booby with some following among classicists, who told Elgin that 'You have lost your labour, my Lord. Your marbles are overrated: they are not Greek: they are Roman of the time of Hadrian.' This ludicrous opinion was to sustain Payne Knight until his death; its absurdity did not prevent it from adding to Elgin's woes, because he could not expect to sell the marbles if their provenance was in doubt. And expertise on classical Greece was in relatively short supply at that period.

From 1807 the marbles were on limited public view at Park Lane (where they inspired the rapture of Benjamin Robert Haydon). In 1809 the exhibition was closed to the public and Hamilton, who had acted as unofficial curator, wrote to Elgin about selling the house:

What is to be done with the Marbles? I have often mentioned to you the application made to me to know, when & if Govt. is to buy them – and

certainly the prejudice in their favour is now become so general that I have no doubt that Govt. would pay for them liberally, and certainly the house would sell much better, if known that they were to be removed within a certain time, than if any arrangement of that kind were to remain over this Session undetermined, at least as far as a private understanding with Govt. would go.

Elgin still flirted with the idea of retaining the sculptures himself and of making them a paying proposition all the same. Throughout the summer of 1809 he admitted certain privileged guests such as the celebrated actress Mrs Siddons. Thomas Lawrence wrote somewhat hyperbolically of her visit that 'Mrs Siddons can nowhere be seen with so just accompaniments as the works of Phidias, nor can they receive nobler homage than from her praise. She is of his age, a kindred genius, though living in our times.' This episode recurs in Elgin's *Memorandum* two years later as the occasion when a group of the Fates 'so rivetted and agitated the feelings of Mrs Siddons, the pride of theatrical representation, as actually to draw tears from her eyes'. Emotional expense, at any rate, was not to be spared.

By the autumn of 1809, however, Elgin was no nearer to selling Park Lane and was entertaining the idea of converting it into a permanent private museum, to which the public would be admitted as paying customers. As A. H. Smith records it, professional advice on this scheme was discouraging:

> It was architecturally practicable, at a cost of £1500–2000. But there would be the expense of reinstatement at the end of the lease. The remainder of the house would be greatly depreciated as a property, and there was no probability that the admission fees would meet the expenses of maintenance. It was therefore much to be preferred that the marbles should pass to the keeping of the Government.

The project of furnishing his Scottish keep at Broomhall with the friezes of Phidias had expired. Now the idea of retaining them at Park Lane had proven illusory also. In turning his attention to the idea of a bequest Elgin was actuated by motives which, if they were not purely pecuniary, were certainly not entirely aesthetic.

Early in the year 1810, Joseph Planta of the British Museum called upon Hamilton to inquire what Lord Elgin's intentions concerning the marbles might be. Referred to the principal in the matter, he received

a call from Elgin in July. The outcome of this meeting was a letter from Planta on 21 July, in which he urged immediate action:

> The necessity of receiving from your Lordship a specific offer is what I believe our leading men will not dispense with; and my zeal in the cause urges me earnestly to wish that this step might be got over as soon as possible, for though nothing decisive can be done till our trustees meet in November, yet preliminary measures may be taken among individuals which may greatly facilitate the happy issue of their collective deliberations.

Planta also busied himself writing to trustees of the museum such as Mr Speaker Charles Abbott (later Lord Colchester), and to General Ramsay, a close friend of Elgin. The import of all these letters was that Elgin should initiate proceedings by stating plainly what he would take for the marbles.

Accordingly, Elgin drew up a *Memorandum* of his acquisition, and in May 1811 made a formal approach to the Paymaster-General, the Right Hon. Charles Long (afterwards Lord Farnborough). This approach took the form of a statement of expenses, coupled with a formal denial that Lord Elgin had made use of his post as ambassador to make the collection. The total of expenses amounted, he said, to a minimum of £62,440.

The Prime Minister of the day, Spencer Perceval, was more inclined to propose to the House that £30,000 would meet the case. This mortified Elgin considerably. On 31 July 1811 he wrote to Perceval in plaintive tones:

> Insinuations have, I'm told, been thrown out, tending to create an impression as if I had obtained a considerable share of these marbles in presents from the Porte and without expense; that the allowance of £10,000 granted to me in 1806 bore in some way on the cost of my collection; and that during my Embassy I received presents beyond the usual practice in other European courts, and out of proportion with the various persons concerned in the operations for the recovery of Egypt.

Here occurs the only serious flaw in A. H. Smith's narrative. He simply omits the following lines in the letter to Perceval. They came directly after the sentences quoted above:

> I had no advantage from the Turkish government beyond the Firman given equally to other English travellers. My successors in the Embassy could not obtain permission for the removal of what I had not myself taken away.

And on Mr Adair's being officially instructed to apply in my favour, he understood,
'The Porte denied that the persons who had sold those marbles to me had any right
to dispose of them' [italics mine].

So here we have Lord Elgin, in a signed letter to the prime minister,
admitting that he had acquired the marbles *without* the authority he was
later to claim that he possessed. In attempting to defend himself on one
charge – that of overdue intimacy with the Ottoman rulers – he opens
himself on another flank and incidentally undermines the British
government's repeated contention that his transaction was a legal one
by the standards of the day. This is an important piece of evidence, and
since A. H. Smith had certainly read the original letter he had no
business leaving it out. It is the only ellipsis I can find in his account,
but it is a damaging one.

Elgin went on, in still more injured vein, to confront other
suggestions:

> I have only to add, that in no one instance during my whole Life passed in
> the Foreign Service, did I ever receive any extra allowance from
> Government for Debts, losses, or on any other account whatever; that the
> full pension to which my progression thro' all the Ranks in the career, and
> my length of service entitles me, has not been granted to me, as to my
> Colleagues of similar standing; and that after disposing of my House in
> London, I still remain burdened with a Debt of not less than £90,000.

The marbles were removed for the time being from Park Lane to
Burlington House, where they were augmented by further shipments.
Elgin's correspondence meanwhile took on the tone and shape of a
protracted haggle – one in which he felt it both vulgar and vital to
participate. Hamilton wrote to him proposing that he ask £40,000
while insisting that his expenses had been greater. The assassination of
Spencer Perceval on 11 May 1812 put all such negotiations at hazard
for a considerable time.

In late 1814 an ally made his appearance in the form of Ennio
Quirino Visconti. Born in Rome, he was the son of the Pope's Director
of Antiquities and rose to head the Capitoline Museum. When
Bonaparte's forces removed most of Rome's treasures to Paris Visconti
followed them, became their curator, and won immense renown for his
edition of Greek and Roman iconographies. Elgin invited him to
London, telling Hamilton that:

My object was to obtain from the best judge in Europe (one who having been guardian of the Museum of the Vatican, has since had the charge of Bonaparte's) an appreciation of my collection, advice as to what parts of it are susceptible to restoration, how to arrange it in regard to the various distributions it may be capable of etc. A strong feeling, you must recollect, with me is that the idea of transferring my Collection to the Publick, should come forward, under the impression that the collection is highly desirable, and consider'd so by such authorities, as are conversant with Bonaparte's Collection and his combinations connected with them.

For a fee of £120 Visconti visited London, viewed the marbles and expressed an opinion of their excellence which forms part of the Memorandum. This did not have all the impact that Elgin had hoped; Lord Aberdeen as a trustee of the British Museum giving his opinion that 'there could be no doubt that Visconti was the best practical Antiquary in the world, and that his independent unbiassed opinion would be of great weight anywhere, but that it was equally well known that he would write anything he was asked, for £10.'

The sale of Burlington House to Lord George Cavendish made the question of a new home for the marbles more urgent, and the tempo of haggling increased. Bonaparte's escape from Elba, and the mustering of British forces for the campaign that would culminate at Waterloo, gave further excuses for government frugality and procrastination. Nicholas Vansittart, the Chancellor of the Exchequer, made it plain that Elgin must advance a definite price if he expected to do business with His Majesty's Government. The figure of £30,000 still seemed the one which the authorities preferred.

Hamilton wrote as intermediary to Mr Planta of the British Museum, setting out terms for trusteeship and the transfer of ownership but stopping just short of an actual price. It was at this stage that what A. H. Smith calls 'the delicate question of whether the grant of a Peerage of the United Kingdom could be arranged as a part of the whole transaction' was raised. It was raised to no effect – another of Lord Elgin's major disappointments. He had hoped to quit the ranks of the mere Scottish peerage, but the grant of a barony of Elgin in the United Kingdom was only to be bestowed in 1849 upon his son, perhaps best remembered for his order to destroy the Summer Palace at Peking in 1860.

At Planta's urging, the British Museum set up a committee at a meeting chaired by the Archbishop of Canterbury to communicate

with the government 'respecting the purchase of Lord Elgin's collection'. The members of the committee were Lord Aberdeen, himself an amateur robber of the Parthenon, Mr Charles Long and Elgin's old foe Richard Payne Knight. Long thought £35,000 the highest feasible price, while Knight inclined to the view that £20,000 would be extravagant.

Elgin still hoped to do better, and even as the armies of Wellington and Blücher were converging on Quatre Bras and Ligny he wrote to the Chancellor of the Exchequer, on 8 June 1815, estimating that his expenses, with interest, amounted to £73,600. (Hamilton had always urged him to claim 'expenses immediate and accidental, in *round* and *handsome* sums'.) The Chancellor prudently referred the whole question to a Committee of the House of Commons and a petition to that effect was accordingly made to the House on 15 July 1815.

At once controversy began. For the most part it was confined to questions of propriety rather than principle. That is to say that, while few thought that the Greeks had any standing in the matter, there were those who felt that Elgin had exceeded his authority as an ambassador. Sir John Newport was foremost among the latter group. He confessed himself 'afraid that the noble Lord had availed himself of most unwarrantable measures, and had committed the most flagrant acts of spoliation. It seemed to have been reserved for an ambassador of this country to take away what Turks and barbarians had always held sacred.' The Speaker's note on the petition reads, 'Lord Elgin's petition presented. The collection praised. Lord Elgin's conduct, and right to the collection, as his private property much questioned. Petition to lie on the table.'

Within a week Elgin had addressed himself to the Chancellor again, stating in a rather convoluted way that, rather than risk the Commons deciding on too high a price, and thus losing the sympathy of the nation, 'I cannot hesitate in authorising you to say that I should consent under these circumstances to receive for it Fifty thousand pounds, supposing that the Committee shall report themselves to be convinced, on the testimony of the best artists and other competent judges that such sum is (as I am confident it is very far) below their real value.'

This negotiating position, itself not very neatly expressed, was accompanied by what A. H. Smith terms 'a curious stipulation' that, if the collection turned out to be all that was hoped for, 'it will be open to myself and my heirs at some future period, and under circumstances

of less public pressure, to apply to the liberality of Parliament for a further consideration of the subject with reference to the real value of what I may in this way have ceded.' On 22 June 1815, Vansittart wrote from the Exchequer with a polite refusal of this proposal. On 25 June came the news that the man who had once termed the British 'a nation of shopkeepers' had been decisively vanquished on the field of Waterloo.

Within a month Hamilton was in Paris, 'partly on business, partly for dissipation'. At a dinner given by Lord Castlereagh, British plenipotentiary in the city, he was introduced to Fouché, who had been Minister of Police during Elgin's internment in France. This may have been the 'dissipation' element in the voyage. The business ingredient was as Lord Liverpool described it in a letter to Castlereagh dated 3 August:

> Hamilton will go with the messenger from London who carries the despatches of this day. He will explain to you the strong sensation in this country on the subject of the spoliation of statues and pictures. The Prince Regent is desirous of getting some of them for a museum or a gallery here. The men of taste and vertu encourage this idea. The reasonable part of the world are for a general restoration to the original possessors; but they say, with truth, that we have a better title to them than the French, if legitimate war gives a title to such objects; and they blame the policy of leaving the trophies of the French victories at Paris, and making that capital in future the centre of the arts [italics mine].

In a despatch five weeks later, Castlereagh wrote that the Prussians had already seized and repatriated those works stolen from the German states, that the Belgians were set on the same course, and that:

> Mr Hamilton who is intimate with Canova, the celebrated artist, expressly sent here by the Pope, with a letter to the King, to reclaim what was taken from Rome, distinctly ascertained from him that the Pope, if successful, neither could nor would as Pope, sell any of the chefs d'oeuvres that belonged to the See, and in which he has, in fact, only a life interest.

The Pope's property was duly removed from the Louvre and restored to him. I cannot resist italicising and stressing the righteous sentences of Liverpool and Castlereagh concerning this episode, nor resist pointing out Hamilton's role in it. At the very moment when he was acting as Lord Elgin's agent in the disposal of the marbles (he ran into Charles Long in Paris and found him still holding out for £36,000 as the maximum price), Hamilton was engaged in re-apportioning the loot of

half Europe to its rightful home. He seemed quite unaware of the hypocrisy implicit in his view, conveyed to Lord Elgin in the middle of November 1815, 'that these works are considered so sacred a property, that no direct or indirect means are to be allowed for their being conveyed elsewhere than where they came from'. Hamilton mentioned the marbles in this context only because, as he put it, 'I flatter myself that the events of the last six weeks there must contribute materially to enhance the value of your collection: and I hope, to soften the obduracy of some of the valuers.'

Of course at the time the Greeks were six years away from their revolution and had no powerful friends to plead for them. As the Tory historian C. M. Woodhouse puts it in his book *The Philhellenes*: 'The point is that it never occurred to anybody, before Byron, that the removal of the Elgin Marbles might be seen as an act depriving the Greeks of their historic heritage. Nobody thought it in the least odd that the Greeks were allowed no say whatever in the matter.'

Elgin wrote to Hamilton later in 1815, thanking him for representing his interests in Paris and telling of fresh financial straitenings:

> You will have heard that in consequence of embarrassments in Broughton's affairs, a debt I owe him of £18,000 came to be claimed by Govt. on which occasion I was impelled to apply to Mr Vansittart [the Chancellor of the Exchequer], soliciting that I might be allowed indulgence till the discussion took place in Parlt. about my collection. He has complied in the most kind, and obliging manner, contenting himself with a security upon the marbles, which I have accordingly authorised.

Which is to say that, before Parliament had even voted on the matter, Lord Elgin had agreed with the Exchequer to use the Parthenon marbles as security on a bad debt.

In June 1816, after a long debate and a far from narrow division, the Commons passed an Act of Parliament. The chief headings of the Act are contained in one paragraph which stated that:

> the said Earl hath agreed to sell the same for the sum of Thirty five thousand Pounds, on Condition that the whole of the said Collection should be kept together in the *British Museum*, and open to Inspection, and called by the name of 'The Elgin Marbles' and that the said Earl and every person who should attain the Rank of Earl of Elgin should be added to the Trustees of the *British Museum* [italics in original].

The thing was done.

Having chronicled the whole voyage of the marbles from the Acropolis to Bloomsbury, A. H. Smith concluded by saying:

> The great Elgin controversy had now been settled by two of the mosr authoritative tribunals known to the constitution of this country. A Select Committee of the House of Commons had heard witnesses and had pronounced its opinion. Parliament, after full debate, had adopted the conclusions of the Committee. Some voices were raised in opposition at the time, and have made themselves audible at intervals ever since, but on the whole the great body of responsible and informed opinion has endorsed the verdict of the Committee and of Parliament.

Since the greater part of the preceding two chapters has been my own gloss on the work of A. H. Smith, I should be the first to dip my colours in salute to his industry and scholarship. But I think that his paragraph above is an unsafe conclusion from his work. Rather, it represents a judgement quite independent of his researches. It is possible from a careful reading of Smith to discover, or to show, that:

1. Lord Elgin misled the House of Commons about his motives (see page 33).

2. Lord Elgin exceeded the terms even of the very elastic *firman* which he extracted from the Turks. As Brian Cook, then Keeper of Greek and Roman Antiquities, conceded in his 1984 British Museum booklet *The Elgin Marbles*, 'it may be questioned whether the *firman* actually authorised even the partial dismantling of the buildings in order to remove sculptures . . . When questioned in 1816 by the Select Committee Hunt agreed that the *Voivode* had been induced "to extend rather than contract the precise permissions of the firman"' (see pages 38–9).

3. Lord Elgin paid bribes to venal Turkish officials and exploited his position as an ambassador ('Dr Hunt, who had better opportunities of information on this point than any other person who had been examined, gave it as his decided opinion that a British subject not in the situation of ambassador could not have been able to obtain from the Turkish government a firman of such extensive powers' – Select Committee report) (see pages 27 and 32).

4. Lord Elgin profited from an exceptional political conjuncture to take advantage of an uncertain political regime (see pages 28 and 31).

5. Lord Elgin knew of, but did not object to, severe structural damage inflicted upon the Parthenon in his name (see pages 16 and 32).

6. Lord Elgin at no time cared to ascertain the wishes or feelings of the Greek people or the inhabitants of Athens (see page 53).

7. Lord Elgin was obliged to take whatever the British government asked for the treasures of the Parthenon, because the Crown held them as a security for one of his bad debts (see page 43).

8. Lord Elgin only claimed to have acquired the marbles 'for the nation', rather than for his own home in Scotland, when financial exigency necessitated their sale (see page 37).

These items in the bill of criticism do not derive from hindsight. They were plain at the time, and plain at the time of A. H. Smith. The other element in his summary of the case, concerning 'the great body of responsible and informed opinion', is much more subjective. Yet it can be shown that he was wrong there too. Important members of that 'great body' disagreed with Elgin and with the British government from the start, continued to do so, and do so to this day.

The Argument: I

Difficult though it is to assign a definite date, the dispute over the legality and the rightness of Lord Elgin's conduct began almost as soon as the work of his mechanics and operatives did. The first in the field was George Noel Gordon, Lord Byron, who knew enough of Greece to know that there was such a thing as Greek feeling, and also to know that it had been outraged. In Canto II of *Childe Harold* and in a later work, *The Curse of Minerva*, Byron emptied the vials of scorn and contempt over the Scottish peer. Hamilton, ever alert to the possible rewards of publicity, wrote to Elgin, 'I do not consider him [Byron] a very formidable enemy in his meditated attack, and I shall be much surprised if his attack on what you have done do not turn out one of the most friendly acts he could have done. It will create an interest in the public, excite curiosity, and the real advantage to the country, and the merit of your exertions, will become more known, and felt as they are more known.'

Elgin seems not to have been so sanguine, and Moore suggests that

The Curse of Minerva was kept back from publication because of 'a friendly remonstrance from Lord Elgin, or some of his connexions' to the publisher. We know that William Miller, who had published Elgin's *Memorandum* on the marbles, turned down the chance to publish *Childe Harold*. But Hamilton was right in a fashion. When Byron's verses did fall from the press in March 1812 they secured Elgin's immortality more surely than any Act of Parliament or tribute of a grateful nation could have done.

As he reflects on the shell of the Parthenon, Childe Harold gives vent to an astonishing mixture of melancholy and anger:

> 12
> But who, of all the plunderers of yon fane
> On high, where Pallas linger'd, loth to flee
> The latest relic of her ancient reign;
> The last, the worst, dull spoiler, who was he?
> Blush, Caledonia! such thy son could be!
> England! I joy no child he was of thine:
> Thy free-born men should spare what once was free;
> Yet they could violate each saddening shrine,
> And bear these altars o'er the long-reluctant brine.

> 13
> But most the modern Pict's ignoble boast,
> To rive what Goth, and Turk, and Time hath spar'd:
> Cold as the crags upon his native coast,
> His mind as barren and his heart as hard,
> Is he whose head conceiv'd, whose hand prepar'd,
> Aught to displace Athena's poor remains:
> Her sons too weak the sacred shrine to guard,
> Yet felt some portion of their mother's pains,
> And never knew, till then, the weight of Despot's chains.

Nor was this all. Byron thought of lampooning Lord Aberdeen, who later sat on the British Museum's committee for the purchase of the marbles, and who had lifted a good few stones from the Acropolis himself in his time. The following stanza was withdrawn from the published version of *Childe Harold* only at the last moment. It would have appeared after stanza 13:

> Come then ye classic Thieves of each degree,
> Dark Hamilton and sullen Aberdeen,

> Come pilfer all that pilgrims love to see,
> All that yet consecrates the fading scene:
> Ah! better were it ye had never been
> Nor ye nor Elgin nor that lesser wight
> The victim sad of vase-collecting spleen
> House furnisher withal one Thomas hight
> Than ye should bear one stone from wronged Athena's site.

This poetic assault reads like a verse essay in restraint when set against *The Curse of Minerva*:

> Daughter of Jove! in Britain's injured name,
> A true-born Briton may the deed disclaim.
> Frown not on England; England owns him not:
> Athena, no! thy plunderer was a Scot.
> Ask'st thou the difference? From fair Phyle's towers
> Survey Boeotia; – Caledonia's ours.
> And well I know within that bastard land
> Hath Wisdom's goddess never held command;
> A barren soil, where Nature's germs, confined
> To stern sterility, can stint the mind;
> Whose thistle well betrays the niggard earth,
> Emblem of all to whom the land gives birth;
> Each genial influence nurtured to resist;
> A land of meanness, sophistry, and mist.
> Each breeze from foggy mount and marshy plain
> Dilutes with drivel every drizzly brain,
> Till, burst at length, each wat'ry head o'erflows,
> Foul as their soil, and frigid as their snows.
> Then thousand schemes of petulance and pride
> Despatch her scheming children far and wide:
> Some east, some west, some everywhere but north,
> In quest of lawless gain, they issue forth.
> And thus – accursed be the day and year!
> She sent a Pict to play the felon here.

Byron's name is indissolubly linked with the Romantic idea, and not unjustly so. But it is often forgotten that he did more than strike attitudes and abuse buffoons. A few hours spent with his later journals from Missolonghi will show that he gave long, unrewarding service and spent much money and time in banal, practical, heartbreaking devotion to the cause of Greece. The levity of some of his stanzas should not deceive later readers. He meant what he said, and will be remembered

as one of the very few Englishmen who thought to ask what Greek emotion might be. At a period when every other participant in the argument was disputing the interest rate on sculpture and asking after the well-being and security of Lord Elgin, Byron had a sense of the Parthenon. In this respect he was more modern, as well as more 'romantic', than his contemporaries.

It is difficult to gauge the exact contemporary influence of Byron's polemic, except to say that he seems to have touched some nerve of anti-Caledonian feeling. On a wall inside the Erechtheion, some admirer carved the quip, which might have been taken from Byron's "Scaped from the ravage of the Turk and Goth': 'Quod non fecerunt Goti, hoc fecerunt Scoti'.

Some of his strength of feeling seems to have communicated itself to others. In the Commons debate on the marbles, Byron's imagery of desecration combined with opportunism was very much present. In evidence before the Commons Committee, for example, John Bacon Sawrey Morritt (Morritt of Rokeby, at that time Member for Northallerton) said that he had passed three months in Athens in the spring of 1795 and found that 'the Greeks were decidedly and strongly desirous that the marbles should not be removed from Athens'. In the later debate, on 7 June 1816, with the House sitting as a Committee of Supply, Mr Hugh Hammersley made the first recorded proposal for the return of the marbles. He did so by proposing an amendment to the bill which read:

> That this committee having taken into its consideration the manner in which the earl of Elgin became possessed of certain ancient sculptured marbles from Athens, laments that this ambassador did not keep in remembrance that the high and dignified station of representing his sovereign should have made him forbear from availing himself of that character in order to obtain valuable possessions belonging to the government to which he was accredited; and that such forbearance was peculiarly necessary at a moment when that government was expressing high obligations to Great Britain. This committee, however, imputes to the noble earl no venal motive whatever of pecuniary advantage to himself, but on the contrary, believes that he was actuated by a desire to benefit his country, by acquiring for it, at great risk and labour to himself, some of the most valuable specimens in existence of ancient sculpture.

After this relatively conciliatory preamble, Hammersley made his specific proposal:

This committee, therefore, feels justified, under the particular circumstances of the case, in recommending that £25,000 be offered to the earl of Elgin for the collection in order to recover and keep it together for that government from which it has been improperly taken, and to which this committee is of opinion that a communication should be immediately made, stating, that Great Britain holds these marbles only in trust till they are demanded by the present, or any future, possessors of the city of Athens, and upon such demand, engages, without question or negociation, to restore them, as far as can be effected, to the places from whence they were taken, and that they shall be in the mean time carefully preserved in the British Museum.

This amendment is of interest because it makes the same dissociation between Elgin's motives (however various those may have been) and the responsibility for the sculpture that is made by the restitution campaign today. In reply to Hammersley, one John Wilson Croker made use of arguments which have, unfortunately, also survived until the present time. He commented sarcastically that 'it was rather too much to expect to interest our feelings for the future conqueror of these classic regions, and to contemplate his rights to treasures which we reckoned it flagitious to retain . . .' He went further in missing the point of Hammersley's amendment by saying that 'the idea of sending them back to the Turks was chimerical and ridiculous'. Like most of his contemporaries, Mr Croker could not conceive of Greeks ruling Athens, or of their having any title to their own antiquity. Hammersley had taken pains to specify 'the present, or any future, possessors of the city of Athens'. But in their majority the British parliamentarians were too bent upon self-congratulation to see this self-evident reservation. The vote was eighty-two in favour of the motion for acquisition and thirty against.

Other Britons of the day, however, were not so easily reassured about the excellence of Elgin's acquisition. Edward Clarke, whom we met at the outset, recorded his own shock at seeing the damage done to the structure, and the symmetry, of the Parthenon:

One example of this nature may be mentioned, which, while it shows the havoc that has been carried on, will also prove the want of taste and utter barbarism of the undertaking. In one of the angles of the pediment, which was over the eastern façade of the temple, there was a horse's head, supposed to be intended for the horse of Neptune issuing from the earth, when struck by his trident, during his altercation with Minerva for the

possession of Athens. The head of this animal had been so judiciously placed by Phidias, that, to a spectator below, it seemed to be rising from an abyss, foaming and struggling to burst from its confined situation . . .

All the perspective of the sculpture (if such an expression is admissible) and certainly all the harmony and fitness of its proportions, all the effects of attitude and force of composition, depended on the work being viewed precisely at the distance in which Phidias designed that it should be seen. Its removal, therefore, from its situation, amounted to nothing less than its destruction:– take it down, and all the aim of the sculptor is immediately frustrated! Could any one believe that this was actually done? and that it was done, too, in the name of a nation vain of its distinction in the fine art? Nay more, that in doing this, finding the removal of this piece of sculpture could not be effected without destroying the entire angle of the pediment, the work of destruction was allowed to proceed even to this extent also?

Clarke asked, if the real intention was to rescue the sculptures from impending ruin, 'why not exert the same influence which was employed in removing them, to induce the Turkish government to adopt measures for their effectual preservation? Ah, no! A wiser scheme was in agitation!'

The engraver H. W. Williams, author of *Travels in Italy, Greece and the Ionian Islands,* visited Greece a few years later and addressed himself to the claim that the removal of the sculptures was beneficial to the fine arts:

That the Elgin Marbles will contribute to the improvement of Art in England, cannot be doubted. They must certainly open the eyes of British artists, and prove that the true and only road to simplicity and beauty is the study of nature. But had we a right to diminish the interest of Athens for such motives, and prevent successive generations of other nations from seeing these admirable sculptures? The Temple of Minerva was spared as a beacon to the world to direct it to the knowledge of purity of taste. What can we say to the disappointed traveller who is now deprived of the rich gratification which would have compensated his travel and his toil? It will be little consolation to him to say, he may find the sculptures of the Parthenon in England.

Williams did not confront the argument, which has been used in a slippery manner down the generations, that if his own countrymen had not done the deed, then some other nation would have perpetrated it. (This line of reasoning was crucial in the Commons debate, which saw Elgin's partisans urging that Britain buy the marbles before he took

them elsewhere, all innocent of the fact that the Treasury already had the marbles in bond.) It has been said, and perhaps rightly, that if Elgin had not removed the marbles the French would have. But Williams's misgivings are decent and eloquent enough, and convey an unease which was shared by many others.

The Hon. Frederick Sylvester North Douglas, in his essay 'On Certain Points of Resemblance Between the Ancient and Modern Greeks', was generally sympathetic to Elgin's case as set out in the *Memorandum*, but still added that 'It appears to me a very flagrant piece of injustice to deprive a helpless and friendly nation of any possession of value to them . . . I wonder at the boldness of the hand that could venture to remove what Phidias had placed under the inspection of Pericles.' John Cam Hobhouse was no fanatic on the point but recorded from one of his encounters:

> Yet I cannot forbear mentioning a singular speech of a learned Greek of Joannina, who said to me, 'You English are carrying off the works of the Greeks our forefathers; preserve them well; Greeks will come and re-demand them.'

Hobhouse's premonition was to prove correct. Both during and after the national revolution, Greeks expressed themselves strongly about the removal of the marbles. The most impressive and convincing account of this expression occurs in the life of General Makriyannis, a great popular leader in the Greek revolt. Having led the defence of the Herodes Atticus theatre at the Acropolis during the fighting of 7 October 1826, and having been severely wounded, he weathered numerous political gales after independence and was near the head of the 1843 Constitutional rebellion. He taught himself to read and write, as he says in the painfully composed manuscript that was not to find a publisher until 1907, for this reason:

> What I write down I write down because I cannot bear to see the right stifled by the wrong. For this reason I learned to write in my old age and to do this crude writing, because I did not have the means to study it when I was a child.

In 1943, speaking to the Greek troops in exile in Alexandria, George Seferis gave a talk on Makriyannis. The address can be found in translation in Rex Warner's edition of *On The Greek Style*. Makriyannis had, it seems, preserved two ancient statues until the liberation of

Greece from the Turks. After the Sultan had finally conceded independence, Makriyannis found that some of his soldiers were thinking of selling the statuary to two European travellers at Argos. In Makriyannis's words:

> I took these soldiers aside and told them this: You must not give away these things, not even for ten thousand *talers*; you must not let them leave the country; it was for them we fought.

Seferis, a future diplomat and Nobel Prize-winner, who was to enrich Greek poetry more than any of his contemporaries, told this to the Greek soldiers as they sat in exile awaiting their own day of liberation, and said:

> You see? It is not Lord Byron speaking, nor a great scholar nor an archaeologist. It is a shepherd's son from Roumelia, his body covered with wounds. 'It was for them we fought.' There is more weight in this sentence of a simple man than in the effusions of fifteen gilded academies. Because it is only in feelings like this that the culture of a nation can be rooted – in real feelings, and not in abstractions about the beauty of our former ancestors or in hearts that have become dried up from a cataleptic fear of the common people.

There is no reason to think that Seferis, faced as he was with the necessity of inspiring Greeks for a terrible battle against Nazism, was in any way exaggerating. We know that in 1821, when the Greeks were besieging the Acropolis, they learned that the Turkish defenders were melting down the lead clamps of the buildings to make improvised bullets. Prominent among the Greek besiegers was Kyriakos Pittakis, who later became the first General Keeper of Antiquities of Greece. According to the distinguished archaeologist Professor A. Rizos Rangavis:

> After Pittakis had heard what was happening and had conferred with his fellow-soldiers, the Athenians sent a quantity of lead bullets to the Ottomans on the Acropolis so that they might desist from their acts of destruction. Those who in the old days fed their starving enemies performed an act of philanthropy, but no nobler action in time of war than this, worthy of the highest civilisation, can ever have been undertaken.

We also know that, even at the height of their battle for independence, the Greek authorities attempted to preserve the classical heritage. In 1825 Alexander Mavrocordatos, Secretary-General of the Provisional

Greek Administration, wrote to a Dutch colonel who had been excavating for his own benefit and told him that while a formal complaint was in preparation, 'I shall consider myself happy to be able to defer the execution of these orders, in the hope that you will remedy the situation by restituting the seized antiquities.' Mavrocordatos went on:

> However, the export of any antiquity is prohibited by law. Force may
> violate this law, since we would need more people to guard the antiquities
> than we have citizens. But we shall never cease to claim what belongs to us,
> and greatly respecting the wisdom of the governments of Europe, we are
> convinced that they will recognise our claims.

It seems evident, then, that there was a consciousness of the Greek heritage at all levels, from the humble Makriyannis upward. Those who claim or imply otherwise are simply ignoring the historical and literary record. The founder of the common lie about Greek indifference is probably the Reverend Philip Hunt, Elgin's chaplain at Constantinople and, as we have seen, his energetic second in the removal. We know from Lusieri, in a letter of 11 January 1802 concerning the Erechtheion, that:

> The details of these various little monuments are masterpieces. Without a
> special firman it is impossible to take away the last (the Pandroseion). The
> Turks and the Greeks are extremely attached to it, and there were murmurs
> when Mr Hunt asked for it.

Yet in 1816, asked by the Commons Select Committee whether there 'was any opposition shown by any class of the natives', the Reverend Hunt replied, 'None.' On the evidence of his own closest collaborator, that was a lie. But the misrepresenting of 'the natives' went deeper than that and has persisted ever since.

The next occasion on which I can find the marbles as a subject of public controversy is an exchange, published in 1890–91, in the London magazine *The Nineteenth Century*. But to judge from the tone and the references, all participants in the debate assumed a knowledge of the argument in their readers. In an article uncompromisingly headed 'Give Back the Elgin Marbles', Frederic Harrison denounced the excuses for retention as 'sophism' and declared:

> The Parthenon Marbles are to the Greek nation a thousand times more
> dear and more important than they can ever be to the English nation,

which simply bought them. And what are the seventy-four years that these dismembered fragments have been in Bloomsbury when compared to the 2,240 years wherein they stood on the Acropolis?

Harrison could argue more trenchantly than his predecessors at the time of the acquisition, because Greece was now independent and an accepted member of the European comity of nations. Old excuses such as Turkish indifference or vandalism towards the statues had lost their force. So had high-sounding arguments about the potential benefit to the English fine arts. As Harrison pointed out, 'Athens is now a far more central archaeological school than London.'

The arguments against doing the generous thing seem to have been much the same in 1890 as they are today. Harrison anticipated them by saying:

> Of course the man in Pall Mall or in the club armchair has his sneer ready –
> 'Are you going to send all statues back to the spot where they were found?'
> This is all nonsense. The Elgin Marbles stand upon a footing entirely
> different from all other statues. They are not statues: they are integral parts
> of a unique building, the most famous in the world; a building still
> standing, though in a ruined state, which is the national symbol and
> palladium of a gallant people, and which is a place of pilgrimage to civilised
> man. When civilised man makes his pilgrimage to the Acropolis . . . he
> goes on to the Parthenon, and there he marks the pediments which Lord
> Elgin wrecked and left a wreck stripped of their figures; he sees long bare
> slices of torn marble, whence the frieze was gutted out, and the sixteen
> holes where the two ambassadors wrenched out the metopes.

Symmetry, and consideration for it, formed a large part of Harrison's case. As he pointed out:

> In the case of at least one metope the Acropolis Museum possesses one half,
> the other half of which is in London. So that of a single group, the
> invention of a consummate genius, and the whole of which is extant,
> London shows half in marble and half in plaster cast, and the Acropolis
> shows the other half in marble and the rest in plaster. Surely it were but
> decent, if we honestly respect great art, that the original be set up as a
> whole.

Harrison recalled as a precedent the case of the Ionian islands, which had been restored to Greece by Gladstone in an act of imagination and magnanimity a few years previously 'because we value the good name of England more than unjust plunder'.

Such was the impact of Harrison's article that when the editor of *The Nineteenth Century*, Mr James Knowles, entered the lists against him in March 1891 he had to have recourse to the heaviest sarcasm. His entire reply was based on the teasing assumption that Harrison was only jesting, and the reply itself is entitled 'The Joke About the Elgin Marbles'. To his sarcasm Knowles added condescension – a typically lethal English cocktail – speaking of 'the mixed little population which now lives upon the ruins of ancient Greece'. He made the baseless and fantastic suggestion that if the marbles were returned the Greek government might 'yield to the offer of a million sterling from Berlin, or two millions sterling from New York'. He chose to ignore Harrison's insistence that the Parthenon has a significance to Greeks which transcends that of all other buildings, and speculated sardonically on the presumed need to give back all other Greek antiquities, and even Assyrian ones. He made the most of the deterioration of the surviving marbles, which had indeed taken place meanwhile, but rather spoiled his point by exaggeration and, towards the end, by absurdity:

> What cannot the platform-Pharisee say of Gibraltar, Malta, India, Burmah, Hong Kong, the Cape, Canada, New Zealand, Australia, IRELAND? Will not every imaginable motive cry aloud in his Pecksniffian bosom to purge himself of all this perilous stuff till England, denuded of every possession which God and her forefathers gave her, shall stand up naked and not ashamed in the midst of a Salvation Army clamour – clothed only in self-righteousness and self-applause and the laughing stock of the whole world?
> This is the logic of 'giving back the Elgin Marbles' . . .

Here is John Bull up on his hind legs. Time has not dealt kindly with Mr Knowles, since all the territories he mentions (except, at the time of writing, Gibraltar and Hong Kong) have achieved self-government, and of these two remaining even Hong Kong has been conceded the principle. It might be amusing to make out a case that the return of the marbles today would imperil the rock-apes of Gibraltar and the garrison of the Falklands, but no modern defender of Lord Elgin has had the wit to try it.

The Harrison–Knowles exchange elicited three interesting responses from widely differing individuals: Constantine Cavafy, George Nathaniel Curzon and Sir Roger Casement. Writing in the *Rivista Quindicinale* of April 1891, Cavafy took strong issue with Knowles:

He thinks that if the marbles are restored, Gibraltar, Malta, Cyprus, India must be given away also – forgetting that if those possessions are necessary to British trade and to the dignity and safety of the British Empire, the Elgin Marbles serve no other purpose than that of beautifying the British Museum. He regards as trivial Mr Harrison's remark that the climate of Bloomsbury is injurious to the sculptures and expresses the fear that, if handed over to Greece, they might be destroyed 'any day in the next great clash of the Eastern question', forgetting that wisdom dictates the remedy of present evils before guarding against future ills.

Perhaps Cavafy was taking Mr Knowles too seriously in his imperialism (and it is interesting to notice his inclusion of Cyprus in a list from which Knowles had actually omitted it). At all events, Cavafy's closing paragraph shows the strength of his feeling on the point:

> It is not clear to me what motives prompted him to write this article; whether solicitude for the artistic wealth of his country, or mere literary *cacoethes scribendi*. If the former, it ought to be borne in mind that it is not dignified in a great nation to reap profit from half-truths and half-rights; honesty is the best policy, and honesty in the case of the Elgin Marbles means restitution. If the latter, and he wrote merely in order to outrival the eloquent, clever and sensible article of Mr Harrison, it is much to be regretted that he did not consider the great French author's warning, *Qui court après l'esprit attrape la sottise*.

In the very same month, George Nathaniel Curzon penned a letter from the Alpine resort of Davos to the editor of the *Fortnightly Review*. He testified to how much he had enjoyed the Harrison–Knowles combat, and gave as his reason for opposing Harrison the familiar argument that the marbles could be seen by more people if kept in London. Still, he allowed that he did not feel entirely comfortable with the wholesale removal of the Parthenon's decoration. As a compromise:

> I do advocate the limited restitution of such of the Parthenon relics as can again be placed, amid their original surroundings, *in situ ipso antiquo* on the sacred rock, and whose empty places there are now filled, to the compunction of the British and the disgust of every observer, with hideous replicas in terra-cotta.

Curzon was alluding to the caryatid of the Erechtheion and to a portion of the frieze. Like so many Greek and English observers, he resorted to the anthropomorphic when discussing the caryatid, which was 'to be seen in the long gallery at the British Museum, where, like

Niobe, she seems to weep her desolation in stone'. In advocating restitution he guarded himself against the routine accusation of 'setting a precedent' by stating that he favoured the return only if the sculptures could actually be reaffixed. Unlike some, however, he was not contemptuous of the Greek stewardship of the Acropolis:

> I was there less than a year ago and have been there before. I can speak for the safe and scrupulous guardianship of the Athenian ruins. I remember the gendarmes, as polite as they are numerous, who hover amid the fallen architraves and shattered drums. I feel certain that under their watchful eye the caryatid would be safe with her sisters.

Curzon closed his long and in some ways contradictory letter with the thought that an exchange might be possible: the caryatid and the panels for the missing portion of the Panathenaic procession. Failing this:

> For my own part, as an Englishman, I would sooner, were the proposal of restoration to be made, that it were made spontaneously and without *arrière pensée*. A free gift is preferable in such a case to a bargain, a restitution to an exchange.

Like Cavafy's letter, Curzon's contains a disclosure from the unconscious. In recommending the zeal of the Athenian gendarmerie who protected the Acropolis, Curzon said, 'I do not think even the craftiest of 'Arries could clamber unobserved with hammer or pointed walking stick to the Victory's frieze.' This seems a bit harsh, given the undoubted breeding and lineage of those English and Scots who actually *had* defaced the temple. Often, in the arguments of those who advocate retention of the marbles and of those who temporise about it, one hears the tones and assumptions of those who wondered if the workers would keep coal in their bath, or whether Indians were 'ready for self-government'.

No such inhibitions applied to Roger Casement, who was on his celebrated mission to the Congo when he read Harrison's article. So stirred was he by the argument that he composed a poem and sent it to London, where it appeared in the *Review of Reviews* of July 1891. (After Casement's execution the *Observer* republished the poem on 21 May 1916.)

> Give back the Elgin marbles; let them lie
> Unsullied, pure beneath an Attic sky.

The smoky fingers of our northern clime
More ruin work than all the ancient time.
How oft' the roar of the Pirean Sea
Through column'd hall and dusky temple stealing
Hath struck these marble ears, that now must flee
The whirling hum of London, noonward reeling.
Ah! let them hear again the sounds that float
Around Athena's shrine on morning's breeze –
The lowing ox, the bell of clinking goat
And drowsy drone of far Hymettus' breeze.
Give back the marbles, let them vigil keep
Where art still lies, o'er Pheidias' tomb, asleep.
 (*Lukunga Valley, Cataract Region of the Lower Congo*)

This is a poem of, perhaps, more merit in feeling than in execution. It is decidedly superior to Thomas Hardy's sentimental *Christmas in the Elgin Room*, which was begun in 1905:

'What is the noise that shakes the night,
And seems to soar to the Pole-star height?'
 'Christmas bells,
 The watchman tells,
Who walks this hall that blears us captives with its blight.'

'And what, then, mean such clangs, so clear?'
''Tis said to have been a day of cheer,
 And source of grace
 To the human race
Long ere their woven sails winged us to exile here.

'We are those whom Christmas overthrew
Some centuries after Pheidias knew
 How to shape us
 And bedrape us
And to set us in Athena's temple for men's view.

'O it is sad now we are sold –
We gods! for Borean people's gold,
 And brought to the gloom
 Of this gaunt room
Which sunlight shuns, and sweet Aurore but enters cold.

'For all these bells, would I were still
Radiant as on Athena's Hill.'

'And I, and I!'
The others sigh,
'Before this Christ was known, and we had men's good will.'

Thereat old Helios could but nod,
Throbbed, too, the Ilissus River-god,
　　And the torsos there
　　Of deities fair,
Whose limbs were shards beneath some Acropolitan clod:

Demeter too, Poseidon hoar,
Persephone, and many more
　　Of Zeus' high breed,
　　All loth to heed
What the bells sang that night which shook them to the core.

Both poems have in common the sense that there is something aesthetically inapt or inapposite in the separation of the marbles from their Helladic context. This feeling has from the first been a large part of the case for restitution. And time, which might have been expected to do its emollient work, has not succeeded in reconciling many people to the idea of Bloomsbury as the 'natural' repository.

Thus, when A. H. Smith published his classic defence of Lord Elgin in 1916, he was being disingenuous by treating the issue as closed. It had never ceased to be a matter of warm controversy and there was no reason to believe, in 1916, that it ever would. The next occasion on which it was opened was in 1924. The young Harold Nicolson was working at the Near Eastern Department of the Foreign Office, specialising in Greek affairs. As he wrote:

> It was natural, therefore, that in my dual capacity as a Foreign Office clerk and a student of Byron's writings, I should draw attention to the fact that on April 19, 1924 would occur the centenary of Byron's death at Missolonghi, and that I should suggest to my chiefs that some action should be taken by the Government to celebrate that occasion. The Foreign Secretary at the time was Ramsay MacDonald, who was also Prime Minister. In the minute which I addressed to him on the subject I had with becoming modesty suggested that a section of the British fleet might visit the Gulf of Corinth on that day and fire a salute off Missolonghi. Ramsay MacDonald, being a Celt, was of a high romantic disposition. He sent me back my minute with the words, 'Certainly! But we must do more than that. Make further suggestions.'

Thus emboldened, Nicolson decided to go for broke:

> Burning with excitement I set myself to strike while the iron was hot. Here
> at last, it seemed to me, was the opportunity to put right an ancient wrong,
> here if ever was a chance to retrieve an act of shame and by a wide gesture
> of generosity to give to Byron's centenary the lustral beauty of a feast of
> compensation.
>
> I was too trained a civil servant to put my suggestions in an extreme or
> emotional form. I adopted the schematic system, dividing my suggestions
> up into paragraphs marked (i), (ii) and (iii) and into sub-paragraphs marked
> (a), (b) and (c). I admitted that it would perhaps be difficult after all these
> years to restore to the Parthenon the sculptures (the Theseus, the Maidens
> and the metopes) of which it had been despoiled. I pointed out, however,
> that in the adjoining Temple of the Erechtheum one of the caryatids was
> missing and its place taken by a terra-cotta effigy.
>
> Every Athenian, and all visitors to Athens, knew that this missing statue
> was in the British Museum, having been shipped from Greece by Lord
> Elgin in 1800. Surely it would be fitting to replace this missing statue and
> let it be known that this gesture of compensation was made as a tribute to
> Greece's independence and as a fitting memorial of the centenary of
> Byron's death. If, I added, the loss of the caryatid would prove more than
> the nerves of the museum authorities or the British public could endure,
> then at least we might restore the column of the colonnade, the presence of
> which in London was unknown to the public. the absence of which from
> the Erechtheum was obvious to every eye.
>
> Mr MacDonald was himself, I still believe, agreeable to my proposal. He
> explained to me with his accustomed cloudy kindliness that politics were
> the art of the possible and that what I had suggested was artless and
> impossible. If we restored the single column, then why not restore the
> caryatid? And if we restored the caryatid, then we would be prejudicing
> our whole case and leaving ourselves with no justification at all for
> retaining the other and even more valuable sculptures. I replied that never,
> since the days of Lord Elgin, had any such justification existed. He shook
> his white locks sadly at me. 'You forget,' he said, 'that had not these lovely
> things been preserved in England, they would have been destroyed during
> the Greek War of Independence.'

Yet again the door was slammed shut with, yet again, a paltry and
evasive excuse for good measure. As Nicolson tried to point out, those
marbles that had survived Lord Elgin had also survived the Greek War
of Independence. But even if he had carried this point, it is a certainty
that another reason for inaction would have been contrived. As it

turned out this time, Ramsay MacDonald would not go as far as Lord Curzon had proposed to go more than thirty years previously.

Nicolson's memoir of the dispute is noteworthy, also, for containing the first challenge I can find to the wording of Elgin's original *firman*. The *firman* was in Italian, a language which Elgin admitted in another context he did not understand well. As Nicolson points out, the *firman*

> only authorised Lord Elgin to remove from 'The Temple of the Idols', namely the Parthenon, *qualche pezzi di pietra*, 'a few pieces of stone'. Even the most free and lavish translation of the Italian tongue cannot twist these words into meaning a whole shipload of sculptures, columns and caryatids.

The *qualche* distinction between 'some' and 'any' was also lost on Ramsay MacDonald, whom only a man as tolerant as Nicolson could have described as 'romantic' in his disposition. Thus, even the modest proposal to return 'some' (the caryatid, perhaps) is at once construed as the prelude to returning 'any' or even (heaven forfend) 'all'. Before you know where you are, you are being asked to give independence to India. This is not the first or last time we encounter the British colonial horror of 'precedent'.

A few years after Nicolson's defeat at the hands of MacDonald, Sir Philip Sassoon paid a visit to Athens on his way back from India (still then a British possession). Sassoon had been private secretary to Earl Haig during the latter's memorable time as commander-in-chief, and was the man to whom the famous 'backs to the wall' order of the day was handed (he later gave the original to the British Museum). As a trustee of the National Gallery, the Tate and the Wallace Collection, Sassoon was a pillar of the museum establishment in London. Yet he wrote to *The Times* in his capacity as Under-Secretary of State for Air – his other consuming interest – that having visited the Acropolis 'to see the beautiful and interesting things which Lord Elgin overlooked':

> Despite the destruction wrought by Venetian bombs and Turkish cannonballs, I found myself wondering whether, after all, the noble ruins of the Parthenon and the glorious atmosphere of Athens would not be a better setting than Bloomsbury for the most exquisite marbles in the world.

The views of men like Nicolson and Sassoon were by no means dominant in the Foreign Office or in the political class. And Greek opinion was something that most British governments felt able safely to disregard. When Nicos Kazantzakis made his visit to England in 1939,

he did not find his Anglophilia reciprocated by anything more than a vague but commonplace sympathy for ancient Greece. This state of affairs was to undergo a sharp and dramatic alteration. Within two years of Kazantzakis's trip, Great Britain and Greece found themselves the only two European democracies still resisting the imposition of Hitler's New Order. The epic defence of Crete, the despatch of British troops and the valiance of the Greek population made an impression which is still vivid in the memory of the survivors, and which has inspired some of the best British writing on the war in Europe. (One might instance Patrick Leigh Fermor, Nigel Clive, Nicholas Hammond and C. M. Woodhouse as pre-eminent.)

It was at a most crucial juncture in this desperate struggle that the British government had to consider a parliamentary question. Tabled on 23 January 1941 by the Tory MP Thelma Cazalet, equally well known as Mrs Thelma Cazalet-Keir, the question appears in Hansard thus:

GREECE (ELGIN MARBLES)
Miss Cazalet asked the Prime Minister whether he will introduce legislation to enable the Elgin Marbles to be restored to Greece at the end of hostilities as some recognition of the Greeks' magnificent stand for civilisation?

More thought than was evident had gone into the boring reply given by Clement Attlee, then Lord Privy Seal and deputy to Churchill, who rose to say that 'His Majesty's Government are not prepared to introduce legislation for this purpose.'

Every scholar and researcher knows only too well how closely the British Foreign Office guards its papers. But there is a grudgingly observed Thirty Year Rule, and thanks to the persistence of Professor Robert Browning, then Emeritus Professor of Classics at the University of London, we now know that the FO, which had asked Miss Cazalet to defer her question in order to canvass informed opinion, came as close as makes no difference to answering her in the affirmative.

The then Librarian of the Courtauld Institute, Miss Welsford, told the Foreign Office, 'I've consulted my Professors, who agree that provided they are not exposed to the weather, scholarship would not suffer if the Elgin Marbles were returned to Greece.' She added that 'If they do go back to Greece a special museum must be built for them.' (This is precisely what the present Greek government proposes.)

The British Museum was naturally invited to state its views, and replied by means of a detailed memorandum. This memorandum was divided by headings under which, with due solemnity, the Historical, Legal, Moral and Practical considerations were reviewed. The Historical section is the weakest of these, because it contains the absurd claim, not even made by Elgin, that 'most of it [the sculpture] was lying on the ground' prior to removal. This is contradicted even by the Museum's own 'Historical Guide', which plainly states the established fact that 'the majority of the sculptures were taken down from the building itself'.

The Legal section of the memorandum makes the obvious point that an Act of Parliament would be necessary for the restitution – which was exactly what Miss Cazalet's question had recognised, and called for. Most fascinating is the section on Morality, which, after conceding that 'the Greeks regard it as a spoliation of their national heritage under Turkish tyranny', goes on to observe: 'The point is that the Acropolis of Athens is the greatest national monument of Greece, and that the buildings to which the Marbles belonged are still standing or have been rebuilt.'

It would be difficult for any supporter of the restitution to summarise the case with greater eloquence or economy. Indeed, and as if sensing this, the museum closed *its* case with the unusual objection that 'Greek pride may reasonably be offended by the patronage . . . which proposes the return as a favour rather than a right.' At last, and from within the very bowels of that 'great body of responsible and informed opinion', came the admission that the Greek view was sound and defensible. It might even have been fairer, given this admission, to let the Greeks be the judge of whether the return was 'a favour' or 'a right'.

At the Greek desk of the Foreign Office, no longer ornamented by Harold Nicolson, the job of summarising the pros and cons fell to Mr W. L. C. Knight. Mr Knight took note of Britain's 'exceptional relations with Greece' and also of the fact that letters to *The Times* on the reopened question showed a strong preponderance of feeling in favour of the return. But he questioned whether the moment was opportune. The more propitious time, he felt, might be at the end of the war, when transport would be safer. 'It would thus set the seal on Anglo-Greek friendship and collaboration in the way that would most appeal – short of the cession of Cyprus – to Greek patriotic sentiment.' Having unconsciously evoked the exchange between Knowles and Cavafy, Knight concluded, 'For the gift to be complete and completely

acceptable it should comprise, in addition to the Parthenon friezes, the Caryatid and the column from the Erechtheum which all together constitute the Elgin Marbles.'

Knight's completed memorandum was forwarded to higher authority with a note from his immediate superior Mr (later Sir) James Bowker. Bowker, as deputy head of the South-Eastern European Department, wrote:

> Everything points to a decision in principle to return the Elgin Marbles to Greece on certain conditions, as enumerated in Mr Knight's memorandum. In order that the memorandum should be quite complete I think it should include recommendations . . .

Recommendations. It would scarcely be British without them. The reply to Miss Cazalet's question, he wrote,

> should be to the effect that the present moment is inopportune for a final decision on a subject which raises several important issues, and has given rise to so much controversy in the past; but that HMG will not fail to give the matter their careful and sympathetic consideration.

Bowker's subsequent addenda all tended to dilute the idea that this was, in any sense but the slightest, a 'decision in principle'. Nonetheless, he clung to the formulation, proposing that:

> Subject to the views of H. M. Minister at Athens, it should be decided in principle to return to Greece the Elgin marbles, including the Caryatid and the column from the Erechtheum on the following conditions:
>
> a. It should be made clear that the decision to return the marbles is in the nature of a gesture of friendship to Greece and is not based on any recognition of the principle that the antiquities should be returned to their place of origin.
>
> b. The marbles should not be returned until after the war.
>
> c. Before they are returned, adequate arrangements should be made for their proper housing, exhibition and preservation.
>
> d. HMG should be assured of a share, in perpetuity, in the control of the arrangements to be made for their preservation.

One can define this proffered chalice as half-full or half-empty. Miss Cazalet's question had specified the return of the marbles 'at the end of hostilities', which cannot on the closest reading have conflicted with

Bowker's stipulation in point (b) above. The other headings, including the first one which states that the marbles are a unique case and not a precedent in themselves, have never ceased to be a part of the restitutionist argument. It is unlikely that point (d) would have presented, or would now present, any lasting obstacle either.

Taken together, however, Bowker's relative stress on 'the principle' and 'the conditions' is essentially bureaucratic. At certain points he makes the best the enemy of the good (as the museum did) by implying that nothing short of a perfect restitution would meet the case. There is something of the non sequitur in a treatment of the subject that opens with the assertion that 'everything points to a decision in principle to return the Elgin marbles to Greece' and ends with a set of conditions and temporisings that have the effect of relegating the implementation of the principle indefinitely. This, in common with the deployment of 'careful and sympathetic consideration', is not unfamiliar as a Foreign Office tactic. Still, it is worth knowing that the main points of the dispute were so close to resolution in 1941. Some at the Foreign Office even felt that the stance of HMG could be a bolder one. Sir Orme Sargent, for example, the Deputy Under-Secretary, deprecated condition (d) as it affected joint control. 'This would be all right', he wrote, 'if an offer to this effect came spontaneously from the Greeks, but for us to demand it would certainly offend Greek *amour propre* and undo a good deal of the psychological value of the gift. Besides, from the technical point of view, I would say it was quite unnecessary.'

It is odd, and in many ways charming, to find British officials discussing this question so minutely and rationally at a time when both Britain and Greece were fighting for survival. And it is of interest to see so many aspects of today's debate being rehearsed in 1941. In effect, the Foreign Office and the British Museum privately relinquished the main elements of their moral claim to the Parthenon Marbles in the course of that year. Only the attachment of some rather pompous subordinate clauses turned a tactical and justifiable postponement of the question into an indefinite shelving of it. W. L. C. Knight, noting this distinction or want of distinction in Attlee's cold reply, minuted to a colleague the dispirited words, 'In these circumstances, and in view of the state of Greek feeling on the subject, the less said about the matter the better.'

It is hard to avoid the wistful reflection that, with this unoriginal conclusion, the Foreign Office missed an opportunity both to right a wrong and to make a laudable gesture of solidarity. But at least one

feature of the present-day argument was mercifully absent. Nobody rose, in the House or in the Foreign Office, to say that the Greek people were 'not really Greek' ('the mixed little population which now lives upon the ruins of ancient Greece', as James Knowles had called them in 1891). That ill-mannered allegation, which has gained a second malicious currency since, was at least spared to the Greek resistance of 1941.

On 10 March 1943, meeting with Greek–American leaders to accept a presentation in his honour, Franklin Delano Roosevelt suddenly asked their president, George Vournas, 'George, what do you know about the Elgin Marbles?' Vournas replied that he knew of Lord Elgin's removal of shiploads of sculpture, some of which were sunk in the Mediterranean 'as a result of storms'. 'Everybody knows that,' said Roosevelt, 'any high-school kid. What I want to know is if the *bases* where the statues were placed originally exist ... Napoleon went to Russia and Italy and stole works of art; Goering went to the Netherlands and stole works of art. It will be just and proper to raise the question of restoration of all stolen property at the peace conference.'

Roosevelt went on to say that if the statues could not be replaced on their original plinth, his enthusiasm for restoring them would be dulled. The fact that the entablature of the marbles had been damaged was hardly the Greeks' fault, but nor was it Roosevelt's fault that he did not know this. Like all those who had been roused to admiration by Greek wartime valour, he favoured the case for restitution, in principle ...

In the immediate post-war period, British opinion followed the same peaks and troughs as it had done in previous decades. The Foreign Office assurance of 'careful and sympathetic consideration' made no very conspicuous reappearance. There came a moment, on 9 May 1961, when Harold Macmillan replied to a question on the point. Asked whether the time had not now come to restore the marbles to Athens, he mused, before the House of Commons:

> This is a complicated question which can hardly be dealt with without a
> great deal of consideration ... There is a problem here. I will not dismiss it
> from my mind, but it raises important questions and would require, I
> imagine, legislation.

This took several steps back from the position reached, with much greater care, by Mr Macmillan's former department of state – the Foreign Office – in 1941. He could at least have made the simple word

'legislation' – which was precisely what was being asked for – sound less like a threat or a diabolical invention. If legislation were not required, after all, it would hardly be a matter for Prime Minister's Question Time, or for the House of Commons in the first place.

On the following day, wrongly detecting signs of weakness in Mr Macmillan's evasive answer, *The Times* printed an unusually ill-argued leader. Entitled 'Bought and Paid For' (which some might think a tautology and others might suspect of showing an uneasy conscience), the editorial ridiculed the Prime Minister for waffling about not having 'dismissed the idea from his mind' and bellowed, 'The sooner he does so, the better.' It was a matter, said *The Times*, of the probity of Lord Elgin, who had acquired the marbles by purchase and 'whose prime motive was their preservation'. Readers who have come this far will presumably recognise square one when they see it.

Nothing more was heard from Mr Macmillan, or of his 'great deal of consideration' (which forgot to emphasise itself additionally as 'careful and sympathetic' but otherwise observed the conventions).

Another very different figure of the 1960s to concern himself with the issue was the novelist and essayist Colin MacInnes, who waged a sporadic guerrilla war about the marbles in the few media outlets that were then available to him. A piece scornfully entitled '"Elgin" Marbles' appeared in *New Society* in January 1963. MacInnes's friend and memoirist Ray Gosling remembers him flourishing other clippings about the marbles at taxi-drivers and in Greek restaurants, but this article is the one that has come down to us from the author of *Absolute Beginners*. MacInnes dealt with the hoariest objection, concerning the 'precedent' that might be set, in this fashion:

> At this point the Museum falls back on its supposedly decisive argument (which I see its Secretary used, predictably, after the subject was argued recently in the House of Commons), which runs, 'if all alien works were returned whence they came, there would no longer be any museums.'
>
> This is a real old question-begger, and I do wish curators would have the guts to say 'what we have we hold' and leave it at that. It is an evasive argument because there can be no possible objection to art works of one country being in the museums of another under these three essential conditions:
>
> 1. If such works of art exist in profusion. No one (not even, I imagine, Gamal Nasser) would suggest all mummy-cases in the world be shipped back to Egypt.

2. If the people who originally created the works of art no longer, in any real sense, survive. No point, for instance, in manhandling Babylonian antiquities back to Iraq.

3. If the present descendants of the original creators of the art works are incapable of looking after them. There is a good case for example, that a sculpture be kept in Great Russell Street rather than on Easter Island.

'We can now see', wrote MacInnes, 'how the Museum's last-ditch argument collapses: for these three innocent categories cover most of its possessions, even those acquired dishonestly. But when we reflect on the works of art to which the conditions of exculpation do not apply at all we must see that the Parthenon marbles are the most sensational example.'

MacInnes proposed, as a face-saving solution, the 'precedent' of the Lane Collection. 'As will be recalled, by a legalistic chicanery, we Britons were long enabled to hang on to paintings Sir Hugh Lane meant for Dublin, until the ingenious (and oh, so English!) device was hit on, by some craftily benevolent brain, of *lending* the pictures in perpetuity. Could we hope that, by some similar astute stratagem we might one day lend their property to the Greeks, and forget ever to ask it be returned?'

MacInnes closed with a reflection which has struck other commentators:

Individuals make disinterested gestures rarely enough, and nations almost never. Yet I have such an irrational faith in the ultimate decency of my fellow countrymen, that I cannot believe them for ever incapable of doing the right, apt thing. One trouble, I think, about us Britons is that even when our intentions are good, we fail to make – or even see – the right move until it is too late.

So great was the response to his article that MacInnes was sent on a trip to Athens in the following month, in order 'that I might put to the test my assertion that the Greek people care profoundly about the Parthenon marbles, and long for their return to the Acropolis'. He found, perhaps not altogether to his own surprise, that:

Without exception the Greeks I interviewed about the marbles were extremely courteous, speaking without recrimination of what they in fact regard as a moral theft by our country from their own, and yet adamant and unanimous in their profound concern to get the marbles back where they

belong. Most striking of all, I found absolutely no one, of any category, who was unaware of the problem, or felt it didn't matter.

MacInnes, whose life and style involved rapid swings between high life and low life, had a number of encounters in Athens. Armed with a stack of British Museum postcards of the marbles, he paid a number of visits to the Piraeus waterfront.

My method at first consisted of producing, after an *ouzo* or two, my pictures, and inviting fellow-boozers to examine them. But as the spots I had chosen were mostly of an agreeably *louche* description, the locals somewhat naturally supposed that I was trying to reverse the habitual tourist's role by selling postcards, instead of buying them. To correct this misunderstanding, I evolved the improved technique of laying the cards casually out on the bar and pretending to write messages home on them.

Of this rather absurd – yet I believe revealing – experiment, I have to report that in almost all cases the photographs immediately aroused general interest (being frequently passed from hand to hand around the joint), and were instantly recognised as being Greek . . . in many other instances there was no doubt whatever that the bar-flies identified the photographs as being of marbles removed to England.

MacInnes, who enjoyed contrasts, veered from the profane to the sacred in paying a call on the poet Odysseus Elytis – later to become a Nobel laureate. Elytis told him:

When I saw the marbles at the British Museum, although without fanatical nationalist sentiment, I had a feeling of desolation – as if one saw someone in exile.

Surely such things belong to one place only, where light and atmosphere are right. I think that in London, perhaps because of cleaning, they have yellowed, but believe that, if they return one day, the sun will restore to them their initial colour.

I cannot say if eight million of us are all conscious of the matter, but am sure a great percentage are, and not only intellectuals but simple people. This is not only an aesthetic question, but a moral one. Of course I understand the difficulty, to you, of yielding. But to do so would be a victory for art for every country.

MacInnes proposed that 'a beginning might be made, at least, by restoring the caryatid and column taken from the Erechtheum. Their removal involved not only, as in the case of the Parthenon, the desecration of a hallowed shrine, but the organic destruction of a

cherished building.' Except when quoting Elytis, MacInnes preferred to stress the altruism of the British rather than the common interest of all people in seeing the Parthenon restored as fully as possible. But he was in distinguished company in seeing the retention of the marbles, and the feeble excuses for retention, as a kind of national embarrassment.

Although Greeks of all classes and parties continued to press for the return of the marbles, and although they never lacked British friends and defenders, the topic seems to have entered a sort of recession during the late 1960s and the 1970s. There had been other such lapses of attention before, of the kind which befall every issue, and it may be pointless to speculate about the reasons for this one. Contributory causes might well include the international isolation and disgrace which overtook Greece during the years 1967–74, when a brutish and philistine dictatorship was imposed on the country. The policies of the fascist junta included censorship of both ancient and modern Greek literature, and were such as to keep many scholars and teachers in prison or out of circulation. In response, numerous Western classicists and philhellenes – among whom Sir Maurice Bowra was prominent – ceased their official and semi-official contact. The Colonels, furthermore, had a shrewd if narrow eye to the importance of Western support. And where they could not achieve support, they sought neutrality. As a matter of record (and, some may think, of shame), one quarter from which they sought and received toleration was the government, both Labour and Conservative, of Great Britain. It was not a propitious period for cultural exchange with wearers of steel helmets and dark glasses, and the wearers themselves did not wish to push their luck. An unspoken moratorium overtook the question.

The restoration of democracy to Greece in 1974, and the renewal of cultural and political links consequent upon Greek accession to the European Community in 1981, gave the argument a new impetus. Despite the long history of the debate, it is probably true that most British people date their acquaintance with it from about a year after that, when Melina Mercouri began to make her name as Minister of Culture in the newly elected Socialist cabinet of Dr Andreas Papandreou. It is no insult to the memory of Mrs Mercouri to say that she added very little to an argument that has gone on steadily for nearly two centuries. But it is to her credit that the subject enjoys the enormous international attention that it has, for perhaps the first time, attained.

In August of 1982 Mrs Mercouri flew to Mexico City and made her

plea to a meeting of Ministers of Culture sponsored by UNESCO. (One sometimes wonders if the hasty British withdrawal from that international body was prompted as much by its interest in the marbles as by Mrs Thatcher's apparent willingness to follow any American lead.) On holiday in Euboea that summer were the British architect James Cubitt and his Greek-born wife Eleni, the playwright Brian Clark and Professor John Gould. It occurred to them that a specifically British committee might be formed, in order to maintain and popularise the long-held opposition of many British people to the policy of the British Museum. On their return to London they made contact with Professor Robert Browning, who had expressed similar sentiments in an interview with the BBC. In a short time they had engaged the attention of newspaper editors, columnists, Members of Parliament of all parties and producers of radio and television (and university) debates. In the intervening years, hardly a forum in the country has not considered the case of the marbles. Senior opposition politicians, and some who sat on the government benches, gave their opinion that the time for restitution had come. It seems very improbable that the debate will ever be stilled again.

Give or take a parliamentary question or two, this is the fullest summary I can make of the history of the dispute until its present very active phase. The history justifies the following observations:

1. The argument is not one between Greece and Britain, still less between the Greek and British governments and not at all between the Greek and British peoples. A substantial section of British artistic, literary and political opinion has always opposed the separation of the marbles from the Parthenon, and all main elements of Greek opinion, when consulted, have done so from the first.

2. The British government and the British Museum have both, in different ways and at various times, but most notably in 1941, conceded that the Greek case (and the case of many British critics) is at the least a very strong one in natural justice.

3. The fact that technical, political and semi-legal objections exist, or have existed, is not in dispute. The fact that a very simple piece of legislation would overcome these at a stroke is likewise not at issue.

4. The arguments for restitution have always been in essence the same, whereas the arguments for retention have changed repeatedly, and most

commonly to suit the short-term convenience of the Museum trustees or of the government of the day. The argument about pollution in Athens, for example, does not even make an appearance until the 1970s, when atmospheric pollution became a matter of general concern in European capitals (see following section).

5. The Greek claim is a settled all-party matter of long standing, and it is false and misleading to suggest that it is 'used' by any one faction or politician.

The Argument: 2

The arguments against the return of the Parthenon marbles have metamorphosed over the years; the exercise involved in dealing with them requires some of the agility and training of a hydra-hunter. Allowing for the tendency of retentionists to change the subject, one can say with confidence that their arguments involve juggling some, or all, of the following propositions:

1. The removal of the marbles to Britain was a boon to the fine arts and the study of the classics.

2. The marbles are safer in London than they would have been in Athens.

3. The marbles are safer in London than they would be in Athens.

4. Lord Elgin acted in the spirit of a preservationist.

5. The return of the marbles would set a precedent for the denuding of great museums and collections.

6. The Greeks of today are not authentically Greek and have no title, natural or otherwise, to Periclean or Phidian sculpture.

To take these arguments in order, and at their strongest:

1. *The removal of the marbles to Britain was a boon to the fine arts and the study of the classics.*
It is true that great things were expected of the marbles, and that the force of their example was considerable. Lord Elgin's correspondence in general, and his dealings with the Select Committee of the House of

Commons in particular, shows him at his best even when he is stretching this aspect further than it will go. Others who could not have hoped to profit by the sale of the marbles to the nation were infected with the same enthusiasm. William Hazlitt expressed the hope, in the *Examiner* of 16 June 1816, that the marbles might 'lift the fine arts out of the limbo of vanity and affectation . . . in which they have lain sprawling and fluttering, gasping for breath, wasting away, vapid and abortive'.

A tall order. Yet there was no feigning in Benjamin Robert Haydon's love for the collection. His drawings went as far afield as Weimar, where they decorated the home of Goethe himself, who urged German scholars to go to London rather than Athens. The celebrated Mrs Hemans, in her widely admired poem 'Modern Greece', also chose the year 1816 to ask:

> And who can tell how pure, how bright, a flame
> Caught from these models, may illumine the West?
> What British Angelo may rise to fame,
> On the free isle what beams of art may rest?

Haydon went so far as to say that the year 1816 'produced an Aera in public feeling'. This was an admirable and selfless hope rather than a statement of the case. But is there any evidence of its fruition?

Traces of what might be termed 'the Phidias effect' are to be found all over the British Isles. The traveller who leaves Waverley Station for Princes Street in Edinburgh may wonder (in my own boyhood I did wonder) what those columns are doing on the eastern skyline of the city. They are, in fact, the only lasting result of Lord Elgin's suggestion that the national monument to the Scottish heroes of the Napoleonic War be a full-scale reproduction of the Parthenon. Like so much in Elgin's career, this project foundered for want of funds, but Calton Hill might perhaps have lent point to Edinburgh's claim to be 'the Athens of the North'. Elgin's campaign to have the new Houses of Parliament designed in the Greek style was similarly thwarted, though not this time by financial exigency.

The Parthenon frieze, in whole or in part, has nonetheless become familiar in English architecture and design in a manner that must be owed to Elgin. It appears, courtesy of Decimus Burton, on the Athenaeum Club (it would be churlishly modernist to laugh at a gift to Pallas Athena decorating Britain's most misogynistic day-care centre) and on the Hyde Park arch. The famous head of Selene's horse was

incorporated by William Threed on the pediment of the Royal Mews at Buckingham Palace and in the monument to Sir William Ponsonby in St Paul's. The coincidence of the victory at Waterloo with the acquisition of the marbles is preserved and acknowledged in the commemorative vase in Buckingham Palace Gardens and in Pistrucci's medal, both of which feature the horsemen of the Parthenon frieze. Sir John Soane made use of the caryatid in his own architecture, as did many lesser imitators.

The staunchest John Bull would not claim this as an especially rich harvest, when it is remembered that the enhancement of English fine arts was the great justification for the detachment of the marbles at the time. But there was and is one indubitable, lasting and attractive result of the removal. It occurred and occurs in English poetry. Byron's verse polemic has already been quoted at length. It is only fair to add that John Keats, at the age of twenty-one, was introduced to the marbles by Haydon, made several enthralled visits to the collection and composed two sonnets as a result. One would not wish to be without them:

ON SEEING THE ELGIN MARBLES

My spirit is too weak – mortality
　　Weighs heavily on me like unwilling sleep,
　　And each imagin'd pinnacle and steep
Of godlike hardship tells me I must die
Like a sick Eagle looking at the sky.
　　Yet 'tis a gentle luxury to weep
　　That I have not the cloudy winds to keep
Fresh for the opening of the morning's eye.
Such dim-conceived glories of the brain
　　Bring round the heart an indescribable feud;
So do these wonders a most dizzy pain,
　　That mingles Grecian grandeur with the rude
Wasting of old Time – with a billowy main –
　　A sun – a shadow of magnitude.

Haydon, forgive me that I cannot speak
　　Definitively on these mighty things;
　　Forgive me that I have not Eagle's wings –
That what I want I know not where to seek:
And think that I would not be over meek
　　In rolling out upfollow'd thunderings,
　　Even to the steep of Heliconian springs,

> Were I of ample strength for such a freak –
> Think too, that all these numbers should be thine;
> Whose else? In this who touch thy vesture's hem?
> For when men star'd at what was most divine
> With browless idiotism – o'erwise phlegm –
> Thou hadst beheld the Hesperean shine
> Of their star in the East, and gone to worship them.

Scant wit is required to see, in the idea of 'browless idiotism' and 'o'erwise phlegm', the image of the Richard Payne Knight faction, who thought the marbles 'Roman, from the time of Hadrian'. These two sonnets, from March 1817, are their own tribute to authenticity. It also seems probable that 'the heifer lowing at the skies' in Keats's 'Ode on a Grecian Urn' is taken from the extraordinary head on slab XL of the south frieze.

There is no argument against those who say that more people have seen the marbles as a consequence of their being taken from Athens. The same could be asserted if the frieze was now a permanent exhibit at Disneyland. All that may be said with certainty is that both the act of removal and the act of installation in London led to some great efforts, for and against, in poetry and prose. Who can say what might be generated, in this line, by the reunion of the marbles with their parent building? At any event, we should not be losing the verses of either Byron or Keats. It may be moot whether the elevation of British taste was sufficient reason for the prying loose of the Parthenon's sculpture in the first place. But even if that had been the whole intention, the result did not fulfil Mrs Hemans's ardent patriotic hope. No 'British Angelo' can be said to have arisen as a consequence.

2. The marbles are safer in London than they would have been in Athens.
It is impossible to prove a contrary. The marbles might have survived the Greek revolution and every subsequent vicissitude, or they might not have done. They might have been carried off by the French, or they might not have been. It is profitless to speculate, just as it is profitless to speculate about the alternative fate of the cargo of the *Mentor*.

All we can say for sure is that the Greeks always wished the best care to be taken of the marbles, and that extraordinary measures were taken to protect the Parthenon throughout the Greek war of liberation. It can

also be shown that on at least two occasions they were in some peril in London.

If you turn up the minutes of the British Museum Standing Committee for 8 October 1938 (page 5488), you will find the alarming heading 'Damage to Sculpture of the Parthenon'. Under this heading appears the following:

> The Director reported that through unauthorised and improper efforts to improve the colour of the Parthenon sculpture for Lord Duveen's new gallery, some important pieces had been greatly damaged. He asked for a Board of Inquiry to consider the nature of the damage and the policy of the Trustees in regard to publication of the facts; to determine the responsibility for the damage, and to advise upon the necessary disciplinary action. The Committee appointed Lord Harlech, Lord Macmillan, Sir William Bragg, Sir Charles Peers and Sir Wilfred Greene as the Board of Inquiry, with power to take whatever action they should consider necessary, and directed that a Meeting be summoned for Tuesday 11th October, at 5 o'clock.

The staff members who were interviewed by this Board were Frederick Pryce, Keeper of Greek and Roman Antiquities, his assistant Roger Hinks, and Arthur Holcombe, the Museum's Chief Cleaner. On 10 December 1938, the Board of Inquiry presented its report and recommendations:

> Lord Macmillan presented the Second Report of the Board of Inquiry into damage done to sculpture of the Parthenon. He added that since the drafting of this document Mr Pryce had produced medical evidence confirming the Trustee's view that he was not in good health, and asked that the Board of Inquiry might have an opportunity of reconsidering their report of Mr Pryce's responsibility in the light of this new information. The Committee agreed that the Board of Inquiry should embody these facts in an appendix to their Report, but that the Committee was already well enough informed to take action. After full discussion the Committee accepted the recommendation of the Board in regard to publication, and in regard to disciplinary action decided to recommend to the General Board that Mr Pryce be given leave to retire from the service of the Trustees on account of ill-health, and that Mr Hinks be severely reprimanded for neglect of duty and reduced 10 years in seniority and pay. Mr Pryce was granted a month's sick leave pending the issue of the medical certificate necessary for his retirement. The Committee also directed that a record be made of the pieces of sculpture which had been subjected to improper

methods of cleaning, and of the damage so far as this could be ascertained in each case.

The Museum never acknowledged publicly what had occurred, and the matter was stonewalled at Question Time in the House of Commons. But there is a tantalising reference in the Public Record Office at Kew to a Foreign Office file labelled 'Treatment of Elgin Marbles: use of copper wire brushes to clean the marbles thus damaging the surface'. The file itself, like so many interesting entries in the PRO, has been destroyed.

Arthur Holcombe gave an interview to a newspaper on 19 May 1939, in which he made the astounding admission that he and his cleaners 'were given a solution of soap and water and ammonia. First we brushed the dirt off the Marbles with a soft brush. Then we applied the solution with the same brush. After that we sponged them dry, then wiped them over with distilled water . . . To get off some of the dirtier spots I rubbed the Marbles with a blunt copper tool. Some of them were as black with dirt as that grate,' said Mr Holcombe, pointing to his hearth. He went on to say that several of his men had followed his example, but there was no harm in it, 'because the copper is softer than the stone. I have used the same tools for cleaning marble at the museum under four directors.'

These disclosures drew a letter from Jacob Epstein to the editor of *The Times*, dated the same day as Mr Holcombe's interview was published:

Sir,
In your issue of May 2, 1921, I protested against the 'cleaning' and restoring of the Greek marbles at the British Museum, particularly the Demeter of Cnidus. My protest went unheeded and I was jeered at for concerning myself with what I was told was no business of mine. Eighteen years have passed, and now the cleaning and restoration of the Elgin marbles are causing uneasiness, and questions are asked as to whether the famous marbles have been damaged in the process. The British Museum authorities have admitted that any change in the marbles is only to be distinguished by the practised eye 'of an expert', wherever that resides! An interview published in the Press with the head cleaner of the marbles has elicited the information that a copper tool 'softer than marble' (how incredible) was used. Why a cleaner and six hefty men should be allowed for 15 months to tamper with the Elgin marbles as revealed by the head cleaner passes the comprehension of a sculptor. When will the British Museum authorities

understand that they are only the custodians and never the creators of these masterpieces?

In response to a patronising letter from Sir George Hill, Epstein returned to the lists on 25 May 1939. He wrote:

> It is not a question of only 'a mellow golden patina' but of what is far more important, the scraping of the surfaces, and the effect of that scraping on the planes of the marble.
>
> I have myself seen the workmen at the museum at work on the marbles and have been horrified by the methods employed. Sir George ignores the statement of the chief cleaner, Mr Arthur Holcombe, three days ago in the Press, that he had been in the habit at the museum, under all of the last four directors, of cleaning all the marbles with 'a blunt copper tool' and that he started on the Elgin marbles about two years ago and used this tool. 'Copper is softer than stone,' he says. The absurdity of the 'softer than marble' theory is manifest. Has Sir George never heard of the bronze toe of the statue of St Peter in Rome kissed away by the worshippers' soft lips?
>
> 'Putting me in my place' seems to be of greater importance to the museum officials than the proper care and protection of the Greek marbles.
>
> The whole thing boils down not to an academic discussion on cleaning and patination, but to the grave question as to whether the Elgin marbles and the other Greek marbles are to be kept intact, or to be in the jeopardy of being periodically treated, and perhaps, in the end, being permanently ruined by the museum officials through their lack of sculptural science.
>
> The public is dissatisfied with the present state of affairs, and clearly uneasy about the present condition of the Elgin marbles, and must consider the answer for the Treasury in Parliament by Captain Crookshank to a question about them, as both equivocal and misleading. It was an admission of damage with an attempt to minimise the responsibility of the Trustees of the British Museum.

Somewhere there is a report on the damage, which seems to have principally affected the heads of the Horses of the Sun. It was submitted to the Standing Committee during the tenure of Sir John Forsdyke as director on 14 January 1939. It will not become available for public scrutiny until 1997.

Two years later, the British Museum's Duveen Gallery was severely damaged by Nazi bombing. The Parthenon marbles had only just been removed — some to a vault and the remainder to a disused London underground station at the Aldwych. Prior to these precautions, they had been protected only by timber and sandbags. Imagine if, at a time

when Britain and Greece were allies against Hitler, the marbles had been pulverised in the very place to which they had been removed 'for their own good'.

The second of these two episodes was far less grave than the first, and neither need detract from the credit that is due to the British Museum for its care and liberality. But if there are to be arguments about safety and conservation, then they must take account of time and chance in London as well as of time and chance in Athens.

3. The marbles are safer in London than they would be in Athens.

This is undoubtedly the strongest argument for the retentionists, and also the argument which carries the most weight among Greeks. The degeneration of the atmosphere of Athens and the formation of a toxic cloud of fumes and vapour (*nefos*) over the city, is a continual source of reproach and would even shame a society with less of a heritage to guard. This is felt very keenly by Athenians, who have every reason to wish for the dispersal of the *nefos* on their own account. It should not be all that difficult for Londoners to sympathise, in view of the decay that their city has undergone from various forms of acid rain. Probably the best known example is that of Cleopatra's Needle, which has 'weathered' more in the short time of its sojourn by the Thames than it ever did when it stood by the Nile.

The word that sums up the problem is 'oxidisation'. It has taken two equally dismal forms. It has been a grave nuisance since the last century, when some well-intentioned but unscientific restoration work was carried out. The original Acropolis monuments were built of marble and joined together with iron or wooden joints encased in lead. This ancient practice was wiser than many modern ones in that it prevented oxidisation from attacking the stonework. However, time did decay the joints, and in the nineteenth century these were replaced or reinforced with iron or steel fixtures. It is the rusting in these improvised reinforcements that has caused such tragic splintering in the stone.

The second form of oxidisation is less visible but perhaps more deadly. Precipitates in the air itself, formed from sulphur and carbon dioxide, have fouled the atmosphere and the rainfall and eaten into the marble from the outside. No city with factories or internal combustion engines is free from this modern plague, but Athens suffers from it to a disproportionate extent. The flight from rural poverty and (until recently) unchecked urban development have made it a chaotic and

crowded city, with few restrictions on the emission of exhaust, industrial waste or domestic fumes. There has thus been an alarming, exponential increase in pollution.

Since the fall of the military dictatorship in Greece (which had been unusually promiscuous in granting permits to factory owners, taxi-drivers and other major and minor polluters), there has been an effort to reduce toxic matter in the atmosphere, and an effort to preserve the Acropolis from further decay. These efforts are not synonymous, but they are and must be complementary. As a general necessity for the city, the sulphur content of industrial and transport fuel has been lowered by law, as has the lead content in petrol. As a general necessity for the Acropolis, more specific measures have had to be taken.

A major survey of the Acropolis temples has been under way, involving the restriction of public access to some buildings. Irreparable stonework has been moved to the Acropolis Museum with its controlled atmosphere and temperature, while reconstruction is carried out only with marble from the self-same quarry – Pentelicus – as furnished the original stone. Bolts and pins used to hold one block to another are made only of titanium, which is proof against oxidisation.

In 1983 the Greek government announced a ten-year project, consisting of twelve separate programmes. Graham Binns discusses the restoration work elsewhere in this book, but I will summarise the most important and far-reaching of these programmes:

1. Securing the rock itself. The very hill on which the Acropolis sits has been subject to erosion. The limestone cap of the rock requires some consolidation, as do the substrata. Wire cables and metal nets are being emplaced, and metal rods are being sunk into the rock with anchor plates at the surface and high-strength mortar. Cracks are being sealed in order to arrest the erosion caused by rainfall.

A separate walk with a new surface has been laid, in order to guard against the slow but definite damage attributable to the passage of millions of tourist feet each year.

2. The physical chemistry of pollution is being combated by the use of titanium as specified above, and by experiments in the conversion of gypsum (the outcome of oxidised marble) into calcium carbonate.

3. A project of archival research is under way, which aims to record the stages of decay and to reproduce as nearly as possible the original

state of the temples. Photogrammetry has yielded very accurate outlines in several important cases.

4. Gamma-ray radiography has made it possible to locate the iron fittings placed inside the columns during earlier restorations and thus to predict, identify and prevent cracks and rust within the structures.

5. A painstaking effort has been made to take inventory, and to identify and classify the large number of stones that bestrew the Acropolis. These include blocks recycled from earlier building efforts and *disjecta membra* from the depredations of war and pillage. Careful tabulation has thrown new light on the original structures: it now seems, for example, that there were two unsuspected windows in the eastern cella wall of the Parthenon. Fragments of the sixth caryatid have also been found and classified. All fragments are photographed, numbered and inventoried and those which are too frail or too disfigured to be used in reconstruction are stored in the Acropolis Museum unless their provenance is clearly elsewhere.

6. The Roman temple to Augustus and Rome, and the temple to Athena which pre-dated the Parthenon, are being restored.

7. The ancient paths and walks, including the Sacred Way as it was traced in the Panathenaic procession, are being relaid.

8. Where pollution has been found to have had an extreme effect, sculpture has been moved into the Acropolis Museum pending further work on calcification and its prevention. Since 1979, when the caryatids were removed, some 700 stones have been taken from the temple for repair and treatment. The parking of cars in the vicinity and the use by neighbouring houses of oil-fired heating have been prohibited.

The buildings, which cannot be moved, have been insured as far as possible against further cracking by props and metal plates. These measures are all reversible and are chosen where feasible to be inconspicuous to visitors. The fact that the marbles could not be replaced where they stood, even under Periclean climatic conditions, is a consequence of the workmanship of Lord Elgin's men as much as it is of pollution.

Two comments stand out in the literature on this massive and overdue preservation effort. The first occurs in an article by Brian Cook, written when he was Keeper of Greek and Roman Antiquities in the British

Museum; he is the author of the Museum's standard guidebook on the marbles. Introducing a discussion of the restoration work in *Museums Bulletin*, organ of the Bloomsbury-based Museums Association, Cook says, 'Fortunately Greece now has a number of well-trained experts to undertake the various highly specialised aspects of conservation work.' Reviewing the Greek government's exhibition 'The Acropolis at Athens: Conservation, Restoration and Research', Cook goes on to say that 'although the task is daunting in its magnitude and complexity . . . the present exhibition shows what has been done to tackle the problem in the years 1975–83 and points the way to the future.'

In their own literature on the subject, the Greek authorities avoid all mention of controversy, saying drily and simply, 'Sad to say, a large part of the sculptural adornment of the buildings was removed before the War of Independence.'

Since the dispute is not principally between Britain and Greece but between those who do and do not wish to see the sculpture reunited with its architectural context, it is to the Greek government that supporters of restitution should address themselves at this point. Athens should be the scene of an ever more serious anti-pollution effort for its own sake as well as for the sake of antiquity.

Insofar as the persistence of atmospheric pollution is used as an argument for the retention of the Parthenon marbles in Britain, it appears to be a non sequitur. Every effort has been made – and we have the British Museum's word for it – to restore and conserve the temples of the Acropolis. Where they can no longer be exposed to the air, sculptures are placed in an adjoining museum. A new museum is being prepared for the missing pieces. What more can be expected? The 'environmental' case for retention ignores the fact that Athens is the historic and aesthetic environment for the marbles. In its most extreme form, this argument would justify the removal of the entire Acropolis to a giant vault in London or Glasgow or New York. In its rational form, it would mean that the marbles should have been returned when the atmosphere of Athens was more pure than the atmosphere of London. In its disinterested form, it would mean that the British government would return the marbles when measurable pollution fell below a certain calibrated point. As it happens, though, the point is the latest in a long line of improvised excuses, and did not make its appearance until relatively recently. If the marbles had stayed where they were, and if Athens had become twice as filthy meanwhile, nobody

would propose removing half the marbles to Bloomsbury and leaving the other half to the best devices of the Greeks. It is more than high time that we learned to distinguish between the disinterested preservation arguments and the merely propagandistic ones.

4. Lord Elgin acted in the spirit of a preservationist.

Lord Elgin can be accounted a Samaritan or an ancestor of the preservationists only if one takes him at his own later valuation. There is no objection to admitting that he was a benefactor among other things, or by accident. But his own evidence very clearly shows that that is the very best that can be said. His first intention was to take the marbles to Broomhall in Scotland. Even if his fallback justification could be accepted, it would not necessarily justify the continued retention of the marbles, and would justify the removal of the entire Acropolis. Like all the arguments of Elgin's partisans, this one is another non sequitur at its strongest and a silliness at its weakest.

5. The return of the marbles would set a precedent for the denuding of great museums and collections.

The argument from precedent can be put in absolute or relative terms. In its absolute form, it says that no removal of any artefact from its original home has ever been unjustified, and that petitions for the return of any fragment will jeopardise the entire culture of museums and collections. This argument is familiar to those who have dealt with any nanny, bureaucrat or sergeant-major, and consists of the old stricture 'What if you let everyone do that?'

The relative or relaxed form of the argument acknowledges the distinctions between acquisition, trove and plunder, and takes into account the sensibilities of weaker or powerless parties to such disputes. While reserving the claim of the integrity of museums and collections, this argument concedes that exceptions may arise and may be allowed for.

The case for the restitution of the Parthenon marbles does not confront or 'fit' either of these arguments from precedent very exactly, and for the following reasons:

1. When made by Greeks, and by some British people, it rests to a considerable extent on the idea of 'right'. In this argument, occupied

Greece was stripped of the marbles by *force majeure* and would, if it had the ability to do so, also have the right to repossess them.

2. The Parthenon is unique not just to Greece but to the civilisation calling itself Western and claiming at least partial descent from the enlightenment of antiquity.

3. However attenuated by war and time, the structure still remains where it has always stood, and in recognisable form.

4. However altered by war and time, the Greek people and the Greek language still exist.

This unmistakably differentiates the Parthenon from all other possible 'precedents', whether auspicious or otherwise. There simply is no other case that fulfils all these conditions.

Still, it may be noted that the British Museum and the British Crown have on occasion made unobtrusive restitutions. One might cite the Ethiopian manuscripts that were returned in 1872; the shrine, sceptre and orb of the kings of Kandy returned to Ceylon in the 1930s after being removed by Sir Robert Brownrigg in 1815; the bronzes restored to Benin in 1950; the Mandalay Regalia returned to Burma in 1964. Institutional collections and museums have also made gestures of the kind: Cambridge University restored the special effects of the Kabaka of Buganda to Uganda on that country's attainment of independence in 1964. The British Museum agreed in principle to the return of a portion of the beard of the Sphinx, purloined by a British soldier, as a 'loan' in 1985. The sky, one has to say, did not fall. Yet in none of these instances was the claim as well-founded as that of the Greek government. It would be no slight to the other peoples and nations mentioned to say that their artefacts were either (a) peculiar to themselves and reverenced only within a relatively small compass or (b) as in the case of the beard of the Sphinx, bearing a mainly geographic relation to the culture. Pharaonic Egypt is, after all, as remote as its language. There are no Assyrians, Hittites or Babylonians to take up the cry of 'precedent'. Finally, the beard of the Sphinx, however fragmented, does not stand in quite the same aesthetic relation to the whole as the marbles do to the Parthenon. And the spoils of the Parthenon were not, except in a very indirect manner, the spoils of war. Greece and Britain have never been enemies or rivals in that way, whereas much of the glory of the various British museums is colonial or military in origin.

In a sense, then, the return of the Parthenon marbles does not raise the question of precedent at all. Yet insofar as a body of precedent may be said to exist, it mightily favours the Greek claim. Were the Greeks and their supporters to be demanding the return of all artefacts, or even the return of all that Lord Elgin took away from Greece, it would be a different matter. But they don't, and it isn't. The issue is the unity and the integrity of the Parthenon; all else is an attempt to change the subject.

And changing the subject is something that can be done with a vengeance. In a BBC television discussion on 15 June 1986, Sir David Wilson, Director of the British Museum, was invited to contrast his opinions with those of Melina Mercouri. Sir David had already exhibited a certain want of gallantry when, on an earlier visit to London, Mrs Mercouri had expressed a wish to visit the Museum and view the marbles. On that occasion he had said publicly that it was not usual to allow burglars to 'case the joint' in advance. But once before the cameras he easily improved on this ill-mannered exaggeration. 'To rip the Elgin Marbles from the walls of the British Museum', he said, 'is a much greater disaster than the threat of blowing up the Parthenon.' This might have been thought hyperbolic, if Sir David had not gone on to say, in response to a mild question about the feasibility of restitution:

> Oh, anything can be done. That's what Hitler said, that's what Mussolini said when he got the Italian trains to run on time.

The interviewer, David Lomax, broke in to say:

> You're not seriously suggesting there's a parallel between . . .

Sir David was unrepentant:

> Yes, I am. I think this is cultural fascism. It's nationalism and it's cultural danger. Enormous cultural danger. If you start to destroy great intellectual institutions, you are culturally fascist.
> LOMAX: What do you mean by cultural fascism?
> WILSON: You are destroying the whole fabric of intellectual achievement. You are starting to erode it. I can't say you are destroying, you are starting to erode it. I think it's a very, very serious thing to do. It's a thing that you ought to think of very carefully, it's like burning books. That's what Hitler did, I think you've to be very careful about that.
> LOMAX: But are you seriously suggesting that the people who want the Elgin Marbles to go back to Greece, who feel there's an overwhelming moral case that they should go back, are guilty of cultural fascism?

WILSON: I think not the people who are wanting the Elgin Marbles to go back to Greece if they are Greek. But I think that the world opinion and the people in this country who want the Elgin Marbles to go back to Greece are actually guilty of something very much approaching it, it is censoring the British Museum. And I think that this is a bad thing to do. It is as bad as burning books.

Thus, in spite of numerous and courteous attempts on the part of the interviewer to save him from himself, Sir David Wilson. It will be noted that he had the grace to modify his opinion under questioning. That is, he stopped saying, as he had begun by saying, that it was the Greek patriots who were the fascists. But this only prefaced his accusation that it was the British friends and allies of these Greek patriots who were the emulators of Hitler. Once again, one finds oneself compelled to repeat the obvious. It was British internationalists who opposed the mutilation of the Parthenon before the Greek national revolution and before the birth of the Greek state. Their intention, and the intention of the Greek government, is to build a fitting museum and not to destroy one. Work on this museum, on the slopes of the Acropolis, is beginning. It is Sir David Wilson who, hearing the word 'culture', reaches for his buckshot gun.

The same programme was notable for a more measured – I almost said more British – intervention from the eleventh Earl of Elgin. Invited to give his opinion of Mrs Mercouri he replied:

Unfortunately, the last time she came here, I had an engagement. It wasn't a concocted engagement – I did have one at the Pavilion in Brighton, and I couldn't go to meet her which was very sad I suppose, because it would have been better, once given the chance, to meet the lady and hear her own presentation. Which she's done with tremendous flamboyance and great emotion and I think that had it not been for great emotion, my ancestor would never have done what he did. I mean if he had been dull and insipid and so on, he would have just had his artists make their drawings and then he'd have shrugged his shoulders and then he should have finished, gone away.

Asked if he sometimes wished his 'great-great-grandfather had never done it', Lord Elgin replied:

Goodness yes, I desperately wish that he just stuck to his original idea because, I mean, it was a disaster as far as the family was concerned. I mean from the financial point of view it was a disaster and then in addition to

that you . . . were held up, and jokes were made about marbles, and whether you'd lost them or not. I mean, it's a . . . very sad state of affairs whenever you appear in public, somebody hoots with laughter, it's very sad.

One may prefer the bluff candour of Lord Emsworth to the schemes and wiles of the efficient Baxter.

A suggestive monograph could probably be written on the British obsession with precedent. Long after it was argued that the restitution of the marbles would herald the end of the empire and no doubt the departure of the ravens from the Tower of London, a man who is paid a national stipend to understand and discuss the issue resorts to the crudest abuse and hysteria. Some of this national anxiety was captured by F. M. Cornford in his incisive little treatise *Microcosmographia Academica*, published by Bowes and Bowes in Cambridge in 1908. Cornford was writing on the tactics of Fabius Cunctator as applied to the senior common room and the college committee, but his advice to bureaucratic tacticians could have been adopted with profit by a clearer-thinking man than Sir David Wilson. Chapter Seven of the treatise, entitled 'Arguments', is particularly apposite:

> There is only one argument for doing something; the rest are arguments for doing nothing.
>
> Since the stone axe fell into disuse at the close of the Neolithic age, two other arguments of universal application have been added to the rhetorical armoury by the ingenuity of mankind. They are closely akin; and, like the stone axe, they are addressed to the Political Motive. They are called the Wedge and the Dangerous Precedent. Though they are very familiar, the principles, or rules of inaction, involved in them are seldom stated in full. They are as follows:
>
> The Principle of the Wedge is that you should not act justly now for fear of raising expectations that you may act still more justly in the future – expectations which you are afraid you will not have the courage to satisfy. A little reflection will make it evident that the Wedge argument implies the admission that the persons who use it cannot prove that the action is not just. If they could, that would be the sole and sufficient reason for not doing it, and this argument would be superfluous.
>
> The Principle of the Dangerous Precedent is that you should not now do any admittedly right action for fear you, or your equally timid successors, should not have the courage to do right in some future case, which, *ex hypothesi*, is essentially different, but superficially resembles the present one.

Every public action which is not customary, either is wrong, or, if it is right, is a dangerous precedent. It follows that nothing should ever be done for the first time.

Another argument is that *'the Time is not Ripe'*. The Principle of Unripe Time is that people should not do at the present moment what they think right at that moment, because the moment at which they think it right has not yet arrived. But the unripeness of the time will, in some cases, be found to lie in the Bugbear 'What Dr — will say'. Time, by the way, is like the medlar; it has a trick of going rotten before it is ripe.

Cornford was a tactician of some genius as well as considerable experience in the field. He would make a masterly critic of today's shifty retentionists, as they scramble from one dugout to another and lay down different sorts of smoke in the process. No one who has ever sat on any species of committee can fail to recognise, in the figure of the most sinuous time-waster he or she has ever had to deal with, the very model of our modern retentionist.

6. The Greeks of today are not authentically Greek and have no title, natural or otherwise, to Periclean or Phidian sculpture.
In much of what I wrote in the above passage and elsewhere, I made the working assumption that the Greeks were Greek. This has been contested, often in the most presumptuous manner, by some modern defenders of retention. (It was, as a matter of interest, never contested by Lord Elgin or any of his *équipe*, who may have looked down upon the Greeks but did not deny their claim to be so called.)

A few words may be useful concerning the idea of Greek continuity. On the face of it there is little enough to argue about, unless you take up the burden of the German ethnologist Jakob Philipp Fallmerayer, who thought that all depended on blood and that the Greeks did not have a classical drop.

Greek has been found in written form on tablets that were inscribed 1400 years before the birth of Christ. Although literacy disappeared for several centuries between the end of the Mycenaean age and the emergence of the Greek alphabet as we know it today, there were still parts of the Greek world, notably Cyprus, where this continuity was unbroken. Despite numerous invasions and (if one must concede for a moment to Fallmerayer) adulterations, this most distinctive emblem of a nation or people – its language – is distinct and traceable.

One can go further without being unduly speculative. To quote the Cambridge archaeologist Professor A. M. Snodgrass:

The Greeks always believed that their culture had its beginnings in what we call the Bronze Age – the age of Crete and Mycenae, of the warriors and heroes immortalised in the Homeric epics and the great cycles of tragedy: Oedipus, Achilles, Odysseus, Agamemnon. The sensational discoveries of Heinrich Schliemann at Troy and Mycenae in the nineteenth century seemed to confirm at least the background of the legends, while Arthur Evans's excavations at Knossos, which first revealed the ancient civilisation of Crete to the modern world, made the story of Theseus seem almost credible. In recent years, with the establishment that the language of the Mycenaean world was indeed an early form of Greek, myth and history have drawn even closer together. The most sober archaeologist finds it hard to suppress the image of the past which the Greeks themselves have passed down to us.

Peter Levi, the late Oxford Professor of Poetry, made a similar point about literature when he said:

> The early Greek prose and poetry we have are bound to be impressive to us, if only because they show a stage and also a range of human development which are not so well documented anywhere else. The fact that the Greeks learnt to read and write is a cause as well as an effect of that development, and Greek society even as written history and poetry first reveal it was in a headlong process of change. To us the most thrilling thing about Greek literature, even more so than about archaic Latin, is its mere earliness: these writers have become fully articulate and even philosophic when in some ways their thoughts are still primitively forceful, and a preliterate skeleton often underlies their cleverest literary devices. Because of the fact that only written language has a chance of surviving to be rediscovered, and so to influence a new future, most of European literature has been built on these shaky, chance foundations, and the early Greek writers appear to us now haloed with a special purity and originality.

In philosophy, we have the intriguing remark by Professor A. A. Long of Berkeley that 'the Greeks would not have discovered the cosmos unless they had sensed an analogy between human order and rationality, and natural events'. This makes a good fit with a more impressionistic reflection by Costa Carras, who writes:

> It has often been asserted as a sort of poetic but still serious hypothesis that the famous clarity of Aegean light, the subtle and beautiful balance of mountain, sea, hill, inlet and plain, where no feature overpowers the other, has something to do with the origin and development of the Greek identity and the Greek achievement.

If language, landscape, national consciousness and philosophic and artistic tradition do not amount to continuity, it is difficult to see what does. Certainly no other European people has a comparable claim (though it is fair to say that the extent and nature of the claim are enthusiastically disputed among Greeks – itself a sign of vigour). The Greeks preserved their heritage and identity, moreover, through many centuries of conquest and occupation. Whether they referred to themselves as *Graeci, Ionic, Hellenes* or (under the Roman Empire and after, to the present day) *Romios*, the Greeks had a distinctive and surviving sense of themselves even when they lacked a state to call their own. It was a feature of their national and European renaissance in the 1821 revolution that the Greeks began to draw upon a classical imagery and tradition that lay, as it were, ready to hand.

Consistent in all the varied authorities cited above is some concept of symmetry and of balance, combined with a certain austerity. Unlike most of the other great and eclipsed civilisations of the past, the Greeks were never notorious for luxury or ostentation. The poverty of their soil and mountains and coasts was the revenge for its beauty, and rather discouraged the ornate.

The Parthenon is the nearest to a single combination of these various national harmonies, and although it was once splendidly decorated it was never vulgar or barbaric. A poor Greek of the present day need not feel, any more than his fifth-century BC predecessor, that the Parthenon was designed to exclude or impress or oppress him. Unlike the Pyramids or Babylon or Karnak or the Colosseum, it is not a monument to slave labour or a temple for the adoration of power. And a literate Greek of today, however humble, can puzzle out many of the inscriptions in the Acropolis Museum. When certain English critics sneer that this man or woman is inauthentic, or 'not really' Greek, are they setting a standard by which they would be content to be measured themselves?

If I could be faulted on all the foregoing, and even if the last Greek on earth had died out along with the language, it would remain the case that Greek symmetry has been a gift to culture, and the case for restoring the statuary to the building or to Athens would remain strong.

A Modest Proposal

Much of the argument about the Parthenon marbles is mired in repetition and clogged with stale disputation. Was Elgin an altruist? Does the British Museum have the bounden duty to uphold his legacy? Are the Greeks fit to be the custodians of their own antiquity? There is something to be learned from considering all of these questions. But in considering them, it would be a pity to lose sight of a great opportunity. If the British official side would take less of a stand on property as its emblem of law and principle, it might become possible for us to see the splendours that this opportunity affords.

At present, a tremendous effort is under way to restore the Parthenon and the Acropolis. Independent scholars in all fields, including leading figures from the British Museum, have praised this enterprise, and many of them are taking part in it. What can be preserved and strengthened in the buildings will be preserved and strengthened; the sculpture that can be remounted will be remounted; what must be removed to a museum is being removed to an adjoining one. Spacious and well-proportioned quarters are being prepared, and meanwhile the litter of uncatalogued stone is being cleared away and classified.

In short, the British are being invited to take part in a unique undertaking. By a simple act of parliamentary generosity, they could become the co-founders of a restored Parthenon, and partners in the renewal of the Acropolis. For the first time since Greece became free and independent a visitor to Athens could see all the surviving marvels of Pericles and Phidias in one day, and in the context for which they were originally fashioned. On the day that this incomparable site could be declared 'open' a large part of the credit would adhere to the members of the British Parliament for abandoning the costive insistence that 'what we have we hold', and for opening their ears to the lucid arguments of Byron, Harrison, Seferis and others. It would have been better done in 1924 as a tribute to Greek independence and the Byron centenary. It would have been better done in 1945 as a tribute to Greece's wartime heroism. Another numinous opportunity was allowed to lapse in 1988, when the duocentenary of the birth of Byron went into the bureaucratric discard. But a fresh chance – if any special occasion is really needed – is upcoming. The year 2001 will mark another duocentenary. It will be two centuries since Lord Elgin

mounted his expedition to the Acropolis. Many people are now engaged in considering how best to mark 'the millennium', and the search is on for gestures that express deep feeling or promise a more global conception of the human family. Perhaps we might modestly suggest a small act which would be regarded, and not just by Greeks, as a large one? In the words of a former Leader of the House of Commons: 'The government who take the final step of restoring the Parthenon marbles to where they belong will be acclaimed for their magnanimity.' Who dares to say that this proposal is 'cultural fascism'? There is still time to make the act of restitution: not extorted by pressure or complaint but freely offered as a homage to the indivisibility of art and – why not say it without embarrassment? – of justice too.

Restoration and the
New Museum

Graham Binns

Everything has happened to the monuments and temples of the Acropolis. They have been plundered, fought over, blown up and polluted. Over the past 150 years they have been among the ancient cadavers on which the new breed of archaeologists has tried its techniques and learned its experience. Despite every disaster, what remains is magical. They would hardly be there today, let alone tomorrow, had political history not given the Greeks the opportunity – which they took – to save them. They have carried the job through with steadfastness and skill.

For this current conservation programme involves more than archaeology. Members of the committee responsible for the programme, aside from those who are archaeologists or antiquarians, include architects and civil, electrical and chemical engineers. The political will that has given the programme such priority and such resources in hard times seems to transcend politics and become a national will, involving everyone. There are three great tasks: restoring and conserving the Parthenon; controlling pollution; building a museum uniquely dedicated to the Acropolis monuments.

A table of dates at the end of this chapter shows the structure of the programme. After the first investigations all attention was concentrated on the Erechtheion, that charming house of many gods best known for the Porch of the Caryatids – it is restored and open to view again, saved from the ill-effects of its first restoration. The Erechtheion not only had to have the most urgent attention, but the work put into it was invaluable as a preparation for that now under way on the Parthenon. When that, too, has been completed the other monuments will take their turn. Then will come the laying out of routes and approaches, the

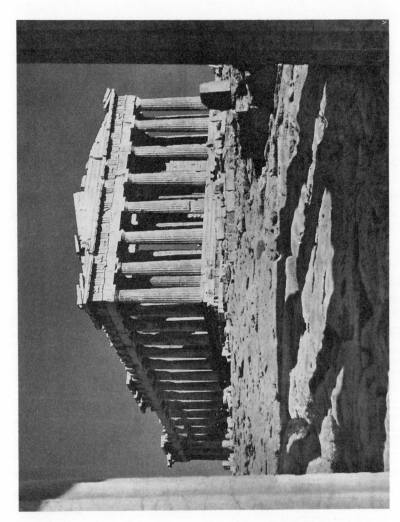

After two and a half thousand years the Parthenon is still a landmark in the city of Athens. The new museum will incorporate a large window-eye focussed upon it. *Photograph by V. Papaioannou.*

subtleties of making the Acropolis 'legible' to visitors, of making the monuments accessible without endangering them or obscuring ancient markings on the rock floor that speak of earlier processional routes and other rituals.

An important part of the whole process is to make the area easier for visitors to understand. And fundamental to that clearer understanding is the provision of a new museum, close at hand. Here again, the monuments themselves, the way in which the visitor approaches them, and the interrelationship of all this with the new museum will give the visitor a clearer and deeper understanding of the Acropolis as a whole.

The Acropolis – but most particularly the Parthenon – had suffered appallingly long before the modern Greek state was established. The first damage was done by an earthquake in 426 BC, the next by an ancient fire. Then the barbarians all but sacked it and the Christians of Byzantium 'converted' it, which meant that they built in it. Count Koenigsmark, the Swede, blew it up,[1] and the seventh Earl of Elgin's men disjointed it and took many of the metopes, large sections of the external frieze, and the greater part of all the pedimental sculptures away to England (the details are given in Appendix 1). The Parthenon was damaged yet again in the two sieges that took place during the War of Independence.

By 1833 the Acropolis was a mess. Christopher Neezer, the Bavarian to whom it was handed over by the Turks, described it then: 'I entered the Acropolis and saw heaps of jumbled marbles. In the midst of the chaotic mass of column capitals, fragments of columns, marbles large and small, were bullets, cannon balls, human skulls and bones.'[2] Yet despite the scene of devastation, the carvings and sculptures themselves would have been as crisp as when Lord Charlemont saw them in 1749:

> The excellent quality of the air, and the dryness of the climate and of the soil, are probably the causes why the remains of this City have an appearance peculiar to themselves, possessing a freshness, and an air of newness, which, considering their great antiquity, is perfectly astonishing, every part of them, except where injured or broken by violence, appearing as if newly come from the hands of the workmen.[3]

The Acropolis was broken, but not yet scarred by acid rain. When it started, with the first years of new nationhood, the work of conservation and restoration would have as its priorities the clearing from the site of such debris as Neezer described, and the gathering together of broken

bits and pieces. It was too early in the day to consider the effects of seismic disturbance; the chemical assault was to be made over a century later.

So, when the work was begun in 1833 and 1834, certain areas were cleared and some of the excrescent structures – huts and habitations – were demolished. Only three years after the independent Greek state had been recognized by the Protocol of London, the Athenian archaeologist Kyriakos Pittakis began to collect and assemble scattered fragments on the site. A year later, in one of his memoranda to the Regency, Leo von Klenze, a Bavarian architect serving as a consultant, proposed among other things that 'architectural blocks that are not of use for rebuilding but which have their own intrinsic value are to be picturesquely grouped in marble piles so that the Acropolis would preserve the appearance of a picturesque ruin. The other architectural material lying around on the ground to be . . . sold as building material.'[4]

Unfair to blame von Klenze for being a man of his time; but it is worth pausing here to reflect that the defenders of Lord Elgin's dismantlements have suggested that if he had not taken the stones from the Parthenon the Turks would have ground many of them down to use as lime for mortar. (In the event, any wilful violation by the Turks was less damaging than the calculated violation by Lord Elgin.) Even this first archaeological 'restoration' threatened to sell off to the builder's yard any pieces that did not seem to fit. But despite a penchant for the picturesque, von Klenze was as aware as any expert of his day of at least one guiding principle: 'If in the course of re-erecting the columns it turns out that one or two drums were missing, they may be replaced by new drums made of marble but there should be no attempt to make the new additions look old.'

From the first tentative beginnings by Pittakis in 1833, the work was continuous until 1902, one archaeologist handing on to another. It has indeed been reasonably continuous since then, interrupted only, as everything has been, by wars and commotions. The initial clearance of the site yielded one particular and symbolic achievement – the discovery in 1835 of the foundations of the temple of Athena Nike and the parts of it that had been built into a Turkish bastion against the besieging Venetians. Maria Casanaki and Fanny Mallouchou observe that, according to present-day criteria, these operations (the removal of later structures) 'were a matter of trial and error, unskilful and detrimental to the ancient material; they were done, nevertheless, in the spirit of the

time in which theoretical principles of restoration had not yet been formulated and the results of restoration depended on the sensitivity and discernment of whomsoever did the work.'[5]

We must defer to the achievements of the past before remarking on its mistakes, and it is easy to be patronising about the old errors through which modern sophistications were discovered. Thanks are due to Pittakis. As Casanaki and Mallouchou point out, 'his unique efforts in collecting and saving widely scattered ancient material will remain a precious contribution forever'. But he also 'used ancient blocks lying around on the ground in a haphazard manner, without bothering to determine the exact original position of each block. He used iron fastenings and filled up the empty spaces between the blocks with ordinary bricks; he braced the columns with heavy iron rings.' The French architect A. Paccard also employed iron fastenings in restoring the caryatid porch of the Erechtheion. Similar methods were used later, in the 1870s, by P. Eustratiadis and, after an earthquake in 1894, an international committee of architects prescribed for the consolidation of the structure of the Parthenon the employment of iron clamps and dowels sheathed in lead or mortar. These methods were continued by N. Balanos, who supervised restoration on the Acropolis from 1898 until 1939 – his work, later to prove so damaging, was approved at the meeting of the International Committee of Museums at Athens in 1931.

The end result of well over a century's unremitting work was that the Acropolis took on the shape and appearance that we now know and recognise. The confusions arising from a medley of adaptations and parasitical structures, such as those put up by Byzantine Christians and Moslem Turks, had been removed and the bones of old Greece were, to a considerable degree, reassembled. As a consequence of the earthquake of 1895, the structures were further strengthened with iron and concrete. But, ironically, this putting together was itself to bring about more dismemberment. The Acropolis was tidy but it was disintegrating, largely because of the way in which it was now braced together but partly because of its increased vulnerability, through the process of time, to earth tremors. The new scourge of pollution was still waiting in the wings.

The paradox that the structures of the Acropolis were, by the 1940s and 1950s, falling apart because of the manner in which they had been held up has its crux in the use of iron clamps which, as they rusted, swelled and split the marble blocks that they knitted together. Balanos,

who was responsible for the use of these clamps throughout his restoration work, should have appreciated what would happen. The Erechtheion porch which Paccard had restored in 1846–47 had become cracked by the 1890s because of the oxidation of the iron, and Balanos himself had had to replace the iron with brass.

The monuments were built originally of marble, close-cut and fitted without cement or mortar. 'The perfect jointing . . . is an essential value of the architecture . . . The individual blocks . . . are set in their final positions before the last stage of carving is completed. When the blocks are set in place on the building they all still have an extra layer of thickness . . . allowing leeway for the final carving and smoothing.'[6] It was this extraordinarily fine jointing that bemused Charlemont: 'In all the buildings remaining at Athens there is nothing more striking than the amazing exactness and contiguity of the joints.' He tried without success to get his penknife between the stones and finally had recourse to a hammer, when he 'found that the joint remained perfectly unshaken, the stone having broken beyond it'.[7] The blocks and sections of column had originally been connected, vertically or horizontally, with wooden dowels or iron clamps. The clamps were first set in the grooves cut for them, then made rustproof by the pouring of molten lead into the surrounding space. This would effectively seal the clamp with a thick cushion to take the strain of movement and absorb the different coefficients of expansion in the materials.

This technique was only skimpily used in the restoration work done by Paccard, Eustratiadis and, over a much larger area, by Balanos. Now 'iron components were used to fasten, consolidate or reinforce architectural blocks with no previous study of their morphology, cross-sections and properties. The iron was haphazardly covered with lead or cement mortar. Water seeping in and the Attic sea air caused the iron to rust and swell, producing mechanical stresses which in many cases strained the marble beyond the breaking point . . . Thus sixty years after Balanos's operations the very materials used with the idea of strengthening the monuments and ensuring them a long life have turned out to be main threat and cause of great damage.'[8] But not everything can be put down to Balanos. The effects of oxidation in the iron supports and connecting pieces applied not only to what was done during the restorations by Balanos but also to some of the original clamps and dowels which had shifted because of earthquakes and explosions.

What aggravated matters further, of course, was the rapid, sprawling

growth of Athens from the 1950s on and the consequent sulphur dioxide pollution. This has taken its toll by spoiling the air and eating into the stones of the Acropolis, just as it is eating into the relatively newer monuments of London.[9] Four million people now live in the metropolitan area of Athens. That is 400 times the number Charlemont reckoned to be living in Athens in 1749, when the carvings of the Parthenon seemed so fresh and new. Factories, oil-fired central-heating systems, air and ground traffic all pump carbon and sulphur dioxides into the air. This not only makes the rusted iron clamps deteriorate further but has damaged the surfaces of the stone and wiped out the sharpness and detail of the sculpture. The Attic plain is set between the sea and the hills; when the wind holds smog over the city the sulphur dioxide corrodes the exposed marble, turning the surface to gypsum. The rain, like all metropolitan rain, falls as diluted acid.

So the problems of 1975, when the present restoration and conservation programme really began, were very different from, and more urgent than, those implicit in the simple devastation which had confronted Christopher Neezer in 1833. The infant science of archaeology had done its best and its damnedest. The problems arising from that work, together with the dragon-breath of the modern metropolis, are the new challenge. There can be no question that the programme has not been impeccably systematic. No major work of this kind has been more fully researched, documented, illustrated, demonstrated, and subjected to international expert scrutiny.[10] Tourists, not being expert scrutineers, have sometimes been dismayed to see the Erechtheion and the Parthenon shrouded and screened by scaffolding and overhung by builders' cranes, and the rock of the Acropolis itself apparently propped up – for time and earthquake, it was thought, had affected even that.

The Committee for the Preservation of the Acropolis Monuments was established in 1975 with firm support from the Greek Ministry of Culture and the government's financial backing. They were able to confirm that the rock of the Acropolis was sound: 'All the talk of fissures, karstic phenomena, and the slipping of the Acropolis rock has been shown by a special geotechnical study to be without foundation.'[11] Nonetheless, the rock has been cleaned of excrescences and now stands clear of the clutter of the Plaka around its base. The studies of earthquake disturbance have also influenced the restoration, by indicating where the buildings need to be strengthened and emphasising the urgency of replacing rusted clamps.

The principles that are being observed in the restoration follow the international rules set out in the 1964 Charter of Venice. This is implacably strict in laying down the law about what should and should not be done. For example, one of the things that should *not* be done is totally to rebuild a ruin – no matter how specifically the measurements and materials are known. Article Fifteen of the Charter expressly rules out 'reconstruction' as distinct from restoration. Crudely put, reconstruction means 'making new', while restoration means 'piecing together' the original material available. So far as the Greek monuments are concerned, additional rules were made deriving from those of the Charter and 'from the particular experience gained (both good and bad) in Greece'.[12] One of these added rules requires that there should be as little change as possible in the appearance of a monument. Professor Bouras elucidates: 'During the last fifty years, the Parthenon *has* remained completely unchanged, and has been visited by more people than at any previous period. The image it now presents has become familiar throughout the entire world and has been recorded millions of times in pamphlets, books, photographs, films and the like. All this should make us very careful when planning changes.'[13]

Article Eight of the Charter requires that sculptures and decorations which are part of a monument may be removed only if this is the sole way of ensuring their preservation. It is indeed the only way to preserve some of the Acropolis sculptures. Five of the graceful figures from the Erechtheion porch have been put into the museum and replaced on the porch by casts. There is a cast there, too, of a column which was long ago carried away by Elgin – an expensive cast, for the British Museum, which houses Elgin's loot, charged the Greeks £30,000 for a plaster cast only, which then had to be duplicated in concrete strong enough to support the roof. The sculptures from the west pediment of the Parthenon have also been taken down and will be replaced by casts when the work on the Parthenon is finished. Like all the work being done, this removal of sculptures can be undone. The process is reversible. Unlike methods often followed in the past, when one bit of carved stone would be chopped merely to make it fit another bit, everything done now is systematic. If newly invented methods of stone conservation, or the eradication of pollution, ever made it seem right to put the original sculptures back in place, this could be accomplished.

Another important principle is that restoration should stop where conjecture begins, and that any necessary new work should be stamped

as such. Von Klenze was on the right track: 'there should be no attempt to make the new additions look old'. Article Ten of the Charter is of particular interest. It allows that 'where traditional techniques prove inadequate, the consolidation of a monument can be achieved by the use of any modern technique for consolidation and construction'. Bouras comments on this: 'It has been demonstrated that the technique of using architectural members cut from single blocks and perfectly dressed guarantees, under natural environmental conditions, a very long life to works of Greek classical architecture. The various cements used by Balanos as substitute for marble . . . deteriorated in less than half a century.'[14] The problem is that the ancient fires, Koenigsmark's bombardment, Elgin's crowbars and the shattering effect of the old restorers' rusting clamps leave us a marble surface that is pocked, split, cracked and desperately in need of surgery. Eschewing plastics, polymers and epoxide resins, the Greeks are using marble cut from the quarries used by the original builders of the Acropolis. The use of the ancient yet ingenious technique of a pointing device, such as sculptors use when making copies, allows pieces of marble to be cut precisely and patched into the original blocks.

Not every wall is shattered. But if even the most serene and unshakeable had been taken at its face value, left, as it were, in peace, it would in a fairly short space of time have begun to split apart. Visitors to the Acropolis in recent years have been puzzled, sometimes angered, by what seems to be the dismantling of a sound structure. This is the story of the clamps. Every clamp put into the monuments during earlier restorations must be replaced. For if it has not already swollen, splitting the blocks that it ties together, it will inevitably do so soon. Moreover, the original clamps have to be inspected as well. Of course, a physical examination of each and every block of marble would mean nothing less than taking everything apart. This problem has been solved by using a diagnostic process which involves ultrasonics and radiography, so that each section of a monument can be examined *in situ* without physically disturbing it unless that proves necessary.

The material used for the new clamps is titanium. Titanium is strong and does not corrode, as is granted by its use in hip-replacement surgery. It does not oxidise in sea air. It has a very low coefficient of thermal expansion, much the same as that of marble, and three times less than that of iron. Thus, it has proved to be the best material to replace the iron clamps and secure the monuments for the future.

None of this prevents the effects of pollution, the other threat confronting the conservationists. No metropolis anywhere is safe from that. Clean-air legislation removes visible pollutants, but does not necessarily alter the pervasive invisible chemistry of a city's atmosphere.

The pollutants that cause most damage to the monuments on the Acropolis are sulphur dioxide and oxides of nitrogen. Measures to control levels of these pollutants in the Athens basin were introduced at the beginning of 1983, and since 1985 they have actually been brought within European limits. This does not mean the end of Athenian smog, but it is a remarkable effort, particularly when the growth of population in the area over the same period is taken into account. Most of the sulphur dioxide is emitted by industrial combustion and central heating. These levels have been lowered by the prohibition of the use of viscous oil, which was in general use for heating, and by requiring refineries to desulphurise fuel. But the problem will really be made manageable around the turn of the century when natural gas will replace liquid fuels.

Motor vehicles belch nitrogen oxides. Since 1990 a number of measures have been introduced which have controlled these emissions to some degree, and others are planned. Perhaps the most effective will be the Athens electric metro, which is now under construction and will be serving the centre of the city within the next few years. This, together with other improvements in public transport and the making of more pedestrian areas (the ancient Plaka was the first such), will help to ensure that these levels remain controlled.

Apart from removing the sculptures to a properly conditioned museum and replacing them with casts, other ways to preserve the marbles in the open air are being studied. As sulphuration turns the surface of marble to gypsum, it was once proposed to coat the threatened surfaces with plastic or some other substance. There are several objections to this. There have been too many instances in the past, on the Acropolis and elsewhere, of things being done that cannot be undone when advances in technique make possible some refinement thought impracticable before. Furthermore, plastics change with time; they turn yellow and scabrous and even accelerate the attack of sulphuration beneath their coating.

More ingenious was the proposal to bring about the *inversion* of marble sulphuration, a process which would consolidate or harden the wafer of gypsum which now carries the sculpted detail of the stone.

These experiments were partly successful; certainly, in the case of the caryatids, they helped to preserve the features of the carving while the figures were moved to the museum. But they have not yet resulted in a solution to the problem of conserving the monuments in the open air.

The figures from the west pediment of the Parthenon were moved to the museum as long ago as 1977, and put into a glass compartment with a nitrogen atmosphere. To replace them on the pediment, copies were commissioned from the British Museum.

The frieze on the western side has been taken down because its carvings have deteriorated. The slow process of restoration has now begun and part of the cleaning may be effected with the use of lasers in a method developed at the University of Crete. The panels will eventually be displayed in the new museum and replaced on the Parthenon by casts. In this case the casts themselves will be made from early castings.

The columns of the inner colonnade on the west side were horribly affected by an ancient fire, and were further shaken by the explosion following Count Koenigsmark's bombardment in 1687. While the columns have just about held together, they are structurally perilous. Now, in 1997, they look like patients in a hospital, draped in drip-tubes through which their multiple internal cracks and fissures are filled with injections of white porcelain cement and a special grout. This is a fine volcanic material brought from Santorini. A material made three times stronger by the absorption of water and named after one of its other places of origin, Pozzuoli, near Naples, it is now being used for the first time in conservation work of this kind.

A startling example of the damage caused by the third-century fire and the delicate condition in which the Parthenon has endured is the drum of a column from the inner side of the west *pronaos*. This suffered so badly from the fire that the marble developed concentric foliation, changing its structure so that leaves of friable stone formed around and within its core in a way rather resembling the formation of an artichoke. When this drum was removed recently for conservation treatment it promptly fell apart into 160 separate fragments. Each has been rebuilt into the drum, which can now be safely replaced in its column.

The next project is the conservation of the colonnade on the northern side, and this presents problems which have been described, aptly, as 'the dance of the columns'. In earlier restorations the different elements were sometimes reassembled incorrectly. So now there will be no

standing columns there while drums and capitals are checked and put into their proper order, and this process itself offers an interesting and important test of British goodwill: Lord Elgin's men wished to provide him with a souvenir column-drum from the Parthenon. They chose to take one from the sixth column from the eastern end (BM no.: 207), because it was the smallest and lightest that they could find. Then their wished to provide him with a souvenir capital. So they took one down from the eleventh column from the eastern end (BM no.: 350). This was heavy to move, so they sawed it in half. This drum and this column are structural members which were removed from the building. Their return is required so that they can be reincorporated into it. The capital can be mended, just as so much of the rest of the building has been structurally mended, and it can then be put back into its proper position. What honest argument can the Trustees of the British Museum put up against returning these pieces? Their record so far has not been one that commands respect. They returned only a *cast* of the column that was Elgin's souvenir from the Erechtheion porch. Will they return structural members from Western civilization's most valued monument?

The two long walls of the *cella* have also been taken down so that their rusted clamps may be removed and each block replaced in its correct original position, which is very difficult to determine. Not all the blocks are complete, of course, and their fragmented parts will be made up into blocks with new marble, using the three-dimensional pantograph, the 'pointing device' referred to earlier. This allows a marble craftsman to fit a piece of new marble precisely around an old fragment, or, on the other hand, to fill a hole in an old block with a new fillet that exactly fits it.

So far so good for the programme to conserve the structure. The sculptured parts are a different matter. Stone or marble sculpture is at hazard in the outdoor atmosphere of any city anywhere, even given clean air legislation. The logical answer, today, is to house all the sculptures belonging to the Acropolis in a properly conditioned museum on the nearest sensible site to the monuments, which is at the foot of the rock itself. This has been part and parcel of the programme from its beginning in 1971; in November 1986 Melina Mercouri, then Greece's Minister of Culture, announced an international competition for its design. The first prize was won by Manfredi Nicoletti and Lucio Passarelli, an Italian partnership, with a proposal intended specifically for

a site at the foot of the Acropolis hill and incorporating the old building
that is the present cast museum. The design has two distinctive features.
One is that the museum will contain a Parthenon-sized space in and
around which all the pieces relating to the temple can be exhibited in
their proper places. The other is that the new museum will incorporate
a large window-eye looking up at the Parthenon itself. Any visitor to
the museum will be able to glance directly from the exhibit before him
or her to the Parthenon nearby. The internal plan is for three floors
which will hold the Parthenon pieces, and it is on the uppermost of
these floors, on a level with the window-eye, that the frieze and
metopes will be exhibited in a natural northern light. The archaic works
will be shown on the lowest level.

This whole complex is part of a carefully integrated plan. There is to
be a link with the new metro already under construction, while the
road that at present separates the site from the Acropolis hill is to be
done away with. You will then be able to walk directly from the
museum to the Acropolis – and not a car in sight! A museum that is so
closely integrated with a monument of this importance will be unique.
Its provision, says the Chairman of OANMA, the organisation entrusted
with its construction, 'is a global demand and a national duty'.

As might be expected in an enterprise of this size and importance,
there were objections and legal obstacles, and these delayed progress.
But, after setting up OANMA in 1995, both government and opposition
confirmed a joint intention to complete the museum. Tenders will be
put out in the autumn of 1997 and it is anticipated that the museum's
first phase (which includes all material relating to the Parthenon) will be
completed within the next three to five years. The budget is for 30
billion drachmas, one-fifth of which sum will be contributed by the
European Community. The Melina Mercouri Foundation, together
with bequests and contributions from other sources, will help still
further with the costs; but the major share will be borne by the state.
The Greek contribution to the new millennium will be a museum of
contemporary design, equipped to the most sophisticated standards. Yet
its essential virtue will be of a simple kind: that it offers a space in which
all the parts of the Parthenon – including those at present 1500 miles
away in London – can be seen in their proper relationships. The frieze
and pedimental figures in particular will be viewed as from the *outside*
of the structure, instead of being displayed as an interior frieze, like the
Bassae frieze, which is how they are being exhibited in the British

Museum. How marvellous to see all the delicate pieces coherently arranged in one place, a stroll away from the Acropolis. The advantages of having every surviving part of the monument in one place are obvious. The concept is that of a unity – a spacious, well-conditioned and well-arranged museum from which the visitor will leave by one of the old processional routes, to the rock itself. It is a concept that satisfies the requirements of research and scholarship, and it will make a visit to the Acropolis the vision that it should be, rather than the scattered jigsaw that it has become. We have the missing pieces in London. Have we got the spirit to give them back?

The Current Programme for the Restoration and Conservation of the Acropolis Monuments and the Setting up of the New Acropolis Museum

This programme mainly concerns work on the Erechtheion and the Parthenon. Work on the conservation of the Propylaia is in progress. The marble ceilings of the central part of this monument are being restored. New ceiling coffers, made up from pieces of the old coffers, will be put in place. The small temple of Nike has been studied but work has not yet begun on it.

The programme and related studies have involved archaeologists, architects, civil engineers, seismologists, chemical engineers and experts in anastylosis (the reassembling and repositioning of fragmented and dismembered parts).

1971 Report by UNESCO experts. Archaeological directorate at the Acropolis does what it can with limited resources.

1975 Working group set up (fact-finding).

1977 Working group publishes *Study for the Restoration of the Erechtheion* (the monument most immediately threatened).

1977 International Meeting on the Restoration of the Erechtheion. The working group's *Study* is approved by ninety participating experts. Working group becomes Committee for the Preservation of the Acropolis Monuments.

1977 Study for the restoration of the Parthenon begins.

1979 Work begun on the Erechtheion.

1983 *Study for the Restoration of the Parthenon* published.

1983 Study considered by the Second International Meeting for the Restoration of the Acropolis Monuments.

1984 Work begins on the restoration of the Parthenon.

1986 Announcement of an international competition to design a new museum. At the end of the year the restoration of the Erechtheion is completed.

1989 Third International Meeting for the Restoration of the Acropolis Monuments. The designs submitted for the new museum are exhibited and the winning design is announced.

1992 The winning architects are commissioned to make final detailed drawings for the new museum.

1994 Fourth International Meeting for the Restoration of the Acropolis Monuments.

1995 Organization for the Construction of the New Acropolis Museum (OANMA) set up by a resolution of the Greek Parliament.

1996 The Melina Mercouri Foundation commissions a preliminary study by the architects.

1997 On the basis of the study, completed in summer 1997, OANMA calls for tenders for the construction of the new museum.

1998 Construction of the New Acropolis Museum commences. Restoration work continues on the Parthenon.

Acknowledgements

I particularly acknowledge my debt to the following: Dr Ismini Triandis, director of the Acropolis Ephoria; Dr Evi Touloupa, her predecessor; Professor Ch. Bouras, architect and professor at the National Technical University, Athens; and the archaeologists Maria Casanaki and Fanny Mallouchou. They are quoted from three publications by the Greek Ministry of Culture and Sciences and the Committee for the Preservation of the Acropolis Monuments, without which a general review of conservation and restoration would not have been possible. These are:

'Conservation Restoration and Research 1975–1983', in *The Acropolis at Athens*, Athens, 1983.

Study for the Restoration of the Parthenon (Summary), Athens, 1983.

Proceedings – Second International Meeting for the Restoration of the Acropolis Monuments – Parthenon – Athens 12–14 September 1983, Athens, 1985.

Notes

1 Koenigsmark was a mercenary officer in a Venetian army under General Morosini. Morosini was a collector as well as a campaigner. He tried to remove the horses from the west pediment of the Parthenon but they broke their slings and smashed on the ground.

2 Maria Casanaki and Fanny Mallouchou, 'Interventions on the Acropolis 1833–1975', in *The Acropolis at Athens.*

3 W. B. Stanford and E. J. Finopoulos, eds, *The Travels of Lord Charlemont in Greece and Turkey, 1749*, London: Trigraph, for the A. G. Leventis Foundation, 1984, p. 132.

4 For more on this see Casanaki and Mallouchou, 'Interventions', where von Klenze is quoted at length.

5 'Interventions'.

6 *Proceedings*, Appendix, p. 116.

7 *The Travels of Lord Charlemont*, pp. 130, 132.

8 'The Physiochemical Problems', in *The Acropolis at Athens*, p. 58.

9 The fourth report from the Environment Committee, 'Acid Rain', London: HMSO, 30 July 1984, recounts the effects of sulphur dioxide on Westminster Abbey, Lincoln Cathedral, York Minster, St Paul's Cathedral and other British monuments.

10 See the frequent international meetings of experts listed on the previous page.

11 *Study for the Restoration*, p. 34.

12 *Study for the Restoration*, p. 39.

13 *Study for the Restoration*, p. 47.

14 *Study for the Restoration*, p. 42.

Appendix I

The Present Location of the Parthenon Marbles

The metopes, frieze and pediment sculptures are presently located as follows:

Metopes

Eastern side: The Battle of the Giants.
All fourteen panels are preserved in position.

Western side: The Battle of the Amazons.
All fourteen panels are preserved in position.

Northern side: The Trojan War.
Eleven of the thirty-two panels, and some fragments, are preserved, either in position or in the Acropolis Museum. The preserved panels (as numbered by A. Michaelis in *Der Parthenon*, 1871) are metopes I–III, XXIV–XXV, and XXVII–XXXII. Metopes IV–XXIII and XXVI are missing.

Southern side: The struggle of the Lapiths and the Centaurs.

	In detail:
I	In position
II	In British Museum
III	In British Museum
IV	In British Museum; the heads of the figures are in Copenhagen
V	In British Museum; part of the centaur's head is in Würzburg
VI	In British Museum
VII	In British Museum; the Lapith's head is in the Louvre, the head of the centaur is in the Acropolis Museum
VIII	In British Museum
IX	In British Museum; the centaur's head is in the Acropolis Museum
X	In the Louvre

XI	Destroyed; some fragments are in the Acropolis Museum
XII	In Acropolis Museum
XIII	Missing
XIV	Missing
XV	Missing
XVI	In Acropolis Museum; one of the heads is in the Vatican Museum
XVII	Missing; a fragment of a figure is in the Acropolis Museum
XVIII	Missing
XIX	Missing; a fragment of a figure is in the Acropolis Museum
XX	Destroyed
XXI	Missing; a fragment is in the Acropolis Museum
XXII	Missing
XXIII	Missing
XXIV	Missing; a fragment of a figure is in the Acropolis Museum
XXV	Missing
XXVI	In British Museum
XXVII	In British Museum
XXVIII	In British Museum
XXIX	In British Museum
XXX	In British Museum
XXXI	In British Museum
XXXII	In British Museum

Frieze

The Great Panathenaic Procession.

The frieze originally consisted of 115 numbered marble panels of irregular sizes. The corner blocks were numbered twice, as two adjacent sides were carved – for example, block 1 of the southern side is block XVI of the western side; there were, therefore, only 111 original blocks of marble. The north and south sides held 47 panels each; the western side 14, and the eastern 7. The panels were numbered by A. Michaelis in his 1871 book *Der Parthenon*; this is the system in use today. The panels are given Latin numerals; the figures carved on the blocks have Arabic numerals. Each side of the frieze is numbered individually, beginning with block 1 and figure 1; thus numbering on the southern side begins at the southwest corner, on the eastern side at the southeast corner; on the northern side at the northeast corner, and on the western side at the northwest corner.

The numbering is not consecutive, as Michaelis was looking at a severely damaged building. Some blocks are numbered out of order; these may have been lying on the ground when Michaelis saw them. Some numbers have been used more than once, with asterisks to denote the different blocks of marble; these blocks were missing when Michaelis made his plan. During the early Christian period, windows were opened along both long sides, marked by ■■■ on the diagram (see p. 112), and the blocks discarded; other blocks are known to us only from Carrey's drawings.

It is important to remember that the list which follows is not final. The restoration work is still in progress, and new fragments of frieze are still being found.

Southern side

I	Half in position; half in the British Museum
II	In position
III	In British Museum
IV	In position
V	In British Museum
VI	In British Museum
VII	In British Museum
VIII	In British Museum
IX	In British Museum
X	Missing
XI	In British Museum
XII	In British Museum
XIII	In British Museum
XIV	In Acropolis Museum
XV	In British Museum
XVI	In Acropolis Museum
XVII	In Acropolis Museum
XVIII	In Acropolis Museum
XIX	In British Museum; the head of figure 48 in the Acropolis Museum
XX	In Acropolis Museum
XXI	In British Museum; fragments in the Acropolis Museum
XXI*	Missing
XXII	In British Museum; a small fragment in the Acropolis Museum
XXIII	Missing
XXIV	In British Museum; fragments of figure 59 in the Acropolis Museum
XXV	In British Museum
XXVI	Missing
XXVII	In British Museum
XXIX	In British Museum
XXIX*	Missing
XXX	In British Museum
XXXI	In British Museum
XXXII	Missing
XXXIII	Missing
XXXIV	Missing
XXXV	In British Museum; fragments of figure 97 in the Acropolis Museum
XXXVI	In Acropolis Museum
XXXVII	Missing
XXXVII*	Missing
XXXVIII	In British Museum
XXXIX	In British Museum
XL	In British Museum; a fragment of figure 111 in the Acropolis Museum

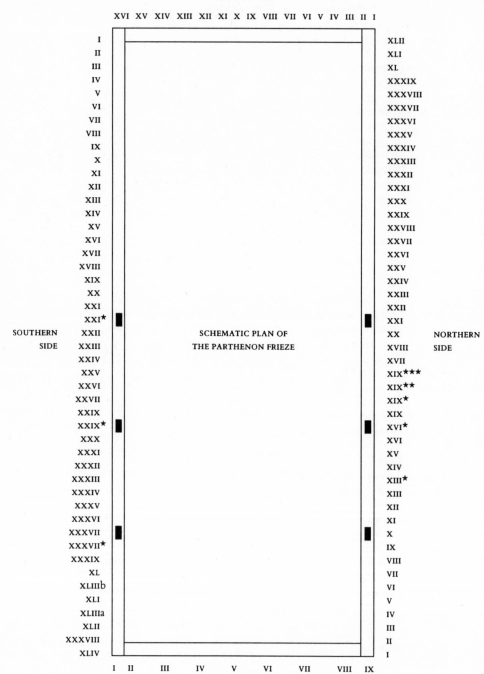

WESTERN SIDE

XVI XV XIV XIII XII XI X IX VIII VII VI V IV III II I

I		XLII
II		XLI
III		XL
IV		XXXIX
V		XXXVIII
VI		XXXVII
VII		XXXVI
VIII		XXXV
IX		XXXIV
X		XXXIII
XI		XXXII
XII		XXXI
XIII		XXX
XIV		XXIX
XV		XXVIII
XVI		XXVII
XVII		XXVI
XVIII		XXV
XIX		XXIV
XX		XXIII
XXI		XXII
XXI★		XXI
XXII		XX
XXIII		XVIII
XXIV		XVII
XXV		XIX★★★
XXVI		XIX★★
XXVII		XIX★
XXIX		XIX
XXIX★		XVI★
XXX		XVI
XXXI		XV
XXXII		XIV
XXXIII		XIII★
XXXIV		XIII
XXXV		XII
XXXVI		XI
XXXVII		X
XXXVII★		IX
XXXIX		VIII
XL		VII
XLIIIb		VI
XLI		V
XLIIIa		IV
XLII		III
XXXVIII		II
XLIV		I

SOUTHERN SIDE

SCHEMATIC PLAN OF
THE PARTHENON FRIEZE

NORTHERN SIDE

I II III IV V VI VII VIII IX

EASTERN SIDE

XLI In British Museum; a fragment of the head of figure 118 in the Acropolis Museum

XLII In British Museum; the head of figure 125 in the Acropolis Museum

XLIII Part of figure 126 in the Acropolis Museum; part of figures 127 and 128

(a and b) in the British Museum

XLIV In British Museum

Eastern side

I In British Museum; a small fragment in the Acropolis Museum

II In Acropolis Museum

III In British Museum; the legs of figure 19 in the Acropolis Museum

IV In British Museum

V In British Museum; the head of figure 28 in the Acropolis Museum

VI In Acropolis Museum; the legs of figure 40 in the Palermo Museum

VII In the Louvre

VIII In British Museum; the heads of figures 58 and 60 in the Acropolis Museum

IX Missing

Northern side

I Missing

II In Acropolis Museum

III In Acropolis Museum

IV In Acropolis Museum

V In British Museum

VI In Acropolis Museum

VII Missing; a small fragment in the Acropolis Museum

VIII In Acropolis Museum

IX Missing; a small fragment in the Acropolis Museum

X In Acropolis Museum

XI In Acropolis Museum; the upper part in the British Museum

XII In British Museum; the head of the figure 47 in the Acropolis Museum

XIII Missing; a fragment in the Acropolis Museum

XIII★ Missing

XIV In British Museum

XV Missing; a fragment in the Acropolis Museum

XVI★ Missing

XVI★ Missing

XVII In Acropolis Museum

XVIII In British Museum

XIX In Acropolis Museum

XIX★ Missing

XIX★★ Missing

XIX★★★ Missing

XX Missing; a small fragment in the Acropolis Museum

XXI In British Museum

XXII In British Museum; parts of figures 64 and 65 in the Acropolis Museum

XXIII	In British Museum
XXIV	In British Museum
XXV	In British Museum
XXVI	In British Museum
XXVII	Missing; fragments in Vienna, in Karlsruhe and in the Acropolis Museum
XXVIII	In British Museum
XXIX	In Acropolis Museum
XXX	In Acropolis Museum
XXXI	In Acropolis Museum
XXXII	In British Museum
XXXIII	In British Museum
XXXIV	In British Museum
XXXV	In British Museum
XXXVI	In British Museum
XXXVII	In British Museum; the head of figure 119 in the Acropolis Museum
XXXVIII	In British Museum
XXXIX	In British Museum
XL	In British Museum
XLI	In British Museum
XLII	In British Museum; a small fragment in the Acropolis Museum

Western side

I	In British Museum
II	In British Museum
III–XVI	In position; fragments of block XIV in the British Museum

Pediment sculptures (denoted as in the drawings of Jacques Carrey)

Eastern pediment:

A	In British Museum
B	In British Museum
C	In position
D	In British Museum
E	In British Museum
F	In British Museum
G	In British Museum
H	In British Museum
J	Missing
K	In British Museum
L	In British Museum
M	In British Museum
N	Missing
O	In British Museum
P	In position

Western pediment:

A	In British Museum
B	In Acropolis Museum
C	In Acropolis Museum
D	Missing
E	In Acropolis Museum
F	Missing
G	Missing
H	In British Museum
J	Missing
K	Missing
L	In British Museum; the figure's head is in the Acropolis Museum
M	In British Museum; a fragment is in the Acropolis Museum
N	In British Museum
O	In British Museum
P	In British Museum
Q	In British Museum
R	In British Museum
S	Missing
T	Missing
U	In Acropolis Museum
V	In Acropolis Museum
W	In position

F. Brommer, in *Die Skulpturen der Parthenon-Giebel* (Mainz, 1963), enumerates another 250 fragments, most of which are in the Acropolis Museum.

Appendix 2

The Commons Debate 1816

Elgin's petition was first presented in the House on 15 June 1815, and deferred; it was again deferred on 15 February 1816. What follows is Hansard's account from 23 February and 7 June 1816.

THE EARL OF ELGIN'S PETITION. The *Chancellor of the Exchequer* rose, in pursuance of his notice, to call the attention of the House to the collection of marbles in possession of the Earl of Elgin. Towards the close of the last session of parliament, the noble earl had presented a petition to the House, praying that an inquiry might be made into the value of his collection, which he was desirous of selling to government for the use of the public. The circumstances under which the noble lord had become possessed of those matchless productions were so well known, that the right hon. gentleman said, he would not trouble the House at any length on the subject. They were acquired by him, in the course of his mission to Constantinople, with the greatest exertions, and at a very considerable expense, and might be justly considered as the most valuable works of

art that had ever been brought from the western parts of Europe. Every person acquainted with that noble lord must be aware, that his object had been solely directed to the advancement of the arts; but being unable, from circumstances which it was then unnecessary to repeat, to fulfil his munificent intentions, he was naturally anxious that the public should enjoy the advantage of his labours. As to the amount of the remunerations to be given to his lordship, the right hon. gentleman wished to leave it to the judgment of the house. The collection was too well known to make it necessary for him to refer to the opinions of the most eminent artists; it was, beyond all question, the most ancient and genuine that had ever appeared, and the country would be naturally proud of possessing a mass of models for the arts, which the united collections of Europe could hardly produce. The committee, however, for which he intended to move, would be enabled to call proper judges before them in order to ascertain the value. It was agreed, on both sides of the House, that, in the present situation of the country, it was in the highest degree desirable to

avoid any unnecessary expenditure; but it should not be forgotten, that if the present opportunity was neglected it might never occur again. He saw no prospect but, in the course of a short time, these exquisite works of art must be dispersed, or disposed of to foreign purchasers. The House had before an opportunity of acquiring a valuable collection, and they had, for public purposes, and on public grounds, availed themselves of it. They had now the offer of a more splendid collection; and it was certainly one of the most wonderful events of the day, that the works of Phidias should become the property of a native of Caledonia. The desire of conferring honour on the arts as well as on the arms of this country was the object of his motion; for, of all the arts, sculpture was at present the least flourishing in England. He should therefore move, 'That the Petition of the earl of Elgin, which was presented to the House on the 15th of February last, be referred to a select committee, and that they do inquire whether it be expedient that the collection therein-mentioned should be purchased on behalf of the public; and if so, what price it may be reasonable to allow for the same.'

Lord *Ossulston* said, he could not object to procuring the advantage of such an interesting collection to the country. A question, however, might arise, whether an ambassador, residing in the territories of a foreign power, should have the right of appropriating to himself, and deriving benefits from objects belonging to that power. It was not the respect paid to lord Elgin, but to the power and greatness of the country which he represented, that had given him the means of procuring these *chefs-d'oeuvres* of ancient sculpture. He thought, therefore, that the House should

go no farther than to remunerate the noble lord for the trouble and expense to which he had been in bringing over these marbles.

Mr *Bankes* said, that the Committee would have to ascertain the mode in which the noble lord obtained these marbles, the expense to which he had been put with respect to them, and what degree of vested right the public already possessed in them. The noble lord could certainly not be considered as an independent traveller, who had a right to dispose of, at any price that he could obtain, whatever he might have collected in the course of his researches. He had availed himself of his character as an English ambassador to facilitate the acquisition. He professed, that instead of leaving the question altogether to parliament, he should have thought it better had the noble lord fixed the price that he required. Under all the circumstances, however, although he was persuaded that the Committee would have an inconvenient and a laborious task. and although he felt very sensibly the difficulties of the times, yet the collection was one of such acknowledged value, one so unrivalled in its nature, and which it was so much to be desired that the public should possess, that he could not hesitate to entertain the proposition made by his right hon. friend.

Mr *Abercrombie* agreed that it was a matter of public duty not to hold out a precedent to ambassadors to avail themselves of their situation to obtain such property, and then to convert it to their own purposes. He was sure, however, that the noble lord would inform the committee of the extent of his facilities. As to obstacles in forming a reasonable estimate, he conceived it would not be found so difficult as the hon. gentleman seemed to think. What

they would have to do was, to inquire whether these marbles were really so valuable to the public as they were represented to be, and then to ascertain what money the noble lord had expended in procuring and bringing them to this country. It would then remain for the House to decide upon the sum to be given to his lordship. Generally, he believed, there could be but one opinion upon this subject, and that there would be no opposition to the appointment of a committee.

Mr *Gordon* thought it his duty in answer to the remark just made, that there could be but one opinion on the subject, to say, that in his judgment, the present distressed situation of the country did not call upon parliament to make a purchase of a set of marbles. However desirable these marbles might be for the promotion of the arts, it would be very impolitic and improper at this time to incur any unnecessary expenditure. He therefore wished the right hon. gentleman to postpone this measure till the country had been relieved from the burthens which now oppressed it.

Mr *Tierney* said, that no man could feel more anxious than himself that these works of art should not be scattered over the country, or be suffered to leave it. If the object of the motion was to inquire whether lord Elgin had become possessed of them in consequence of his public functions, and what expenses he had incurred, he was ready to agree to a committee; but not that particular artists should be asked what they conceived to be the value of these marbles. He thought the committee should be instructed how they ought to conduct themselves. It had been stated that lord Elgin formerly applied to Mr Perceval on this subject, who offered a specific sum of money, which his lordship refused. He did not

see, therefore, why the offer should be repeated. He thought an inquiry should be instituted as to the extent of his expenditure in procuring these marbles. Part of them were brought over in ships of war, and consequently at the public expense. If it were merely intended to hold out encouragement to ambassadors to enrich their country with works of arts, then the motion was creditable to the right hon. the chancellor of the exchequer; but if he meant that the noble lord, availing himself of his official character, should now call himself the possessor, he would not agree to the motion. He thought it improper, in the present situation of our finances, that the House should be invited to purchase them. The right hon. gentleman had said, it was very desirable to possess them. This might be very true, there were a great many things which he would wish to have, and he was sorry he had them not; but he was bound to consider his means, and the right hon. gentleman should do the same.

Mr *C. Long* spoke in favour of the appointment of a committee. It would be to be regretted, if the public lost this opportunity of obtaining a collection more useful than any other that could be found for the improvement of the arts. If the House refused to purchase this collection of lord Elgin, it would be hard on his lordship to be prevented from disposing of it otherwise.

Mr *Preston* opposed the motion, on the ground of the influence of example, and the distressed state of the country, Lord Elgin ought to have come boldly forward, and have made them a present to the country. He thought, that if ambassadors were encouraged to make these speculations, many might return home in the character of merchants. He could not consent to pay for the

collection according to what might be called its value, but only as far as it was a compensation to an ambassador for his expenses in procuring it. He did not see that lord Elgin was bound by what the committee thought right.

Mr *Brougham* was sorry that in the discharge of his duty he must object to the appointment of a committee. He participated, at the same time, in feeling with other hon. members that it was extremely desirable such a collection should be in the possession of this country. It was very rational that we should wish to indulge ourselves in this sort of gratification, but he was under the necessity of looking to the other side of the question. This country had not the money to spend. As a nation we found ourselves precisely in the situation of an individual who might see many things he would like to purchase, and which he might purchase too at a cheap price, but he could not indulge himself with the article, for upon asking himself the question he found that he had no money in his pocket. Perhaps this collection might cost about forty or fifty thousand pounds, but even if it would cost only ten or twelve thousand this was not the time to press expenses upon the public. This was a time when we were called upon to cut down expenses of every description. If it could be afforded, consideration was due to the present state of midshipmen, and also of half-pay officers, retiring upon what was not equal to their support, but he believed the only answer which could be returned was, that in the present state of the country, we were not able to afford them any further assistance; still if we could not give them bread we ought not to indulge ourselves in the purchase of stones. On these grounds he felt it his duty to object to the present motion, and should therefore conclude by moving the previous question.

Sir *John Newport* had not been able to satisfy his mind that these marbles had been acquired in that way that could authorize the nation to purchase them. He therefore should support the amendment.

The *Chancellor of the Exchequer* said, the committee to be appointed would of course consider the question of the expenses of the noble lord carefully, and see also whether they had been properly applied or not. He saw no good ground for taking up the subject at some other time. If the business could be adjourned, with a fair and full security for our retaining possession of this most valuable collection, it would certainly be preferable; but it would be very burthensome to lord Elgin to be debarred from selling it to any body else, while parliament thought fit to refuse to purchase it.

Mr *Babington* thought the mode in which the collection had been acquired partook of the nature of spoliation. It was of the greatest importance to ascertain whether this collection had been procured by such means as were honourable to this country. We were at present looked at with much attention, and perhaps jealousy, by other nations; and many in a neighbouring country might rejoice to find us tripping. He hoped the committee would be careful in seeing that the whole transaction was consonant with national honour. If these remains of antiquity were not honourably acquired, he hoped we should have nothing to do with them.

Mr *Croker* said, it was extremely desirable for the committee to inquire into the points mentioned by the hon. member. He would not vote for the committee, if he did not think it essential

to ascertain that what had been done was compatible with the noble lord's and with the country's honour.

The previous question was put and negatived; after which the main question was agreed to, and a committee appointed.

7 JUNE 1816

[ELGIN MARBLES.] The House having resolved itself into a committee of supply,

Mr *Bankes*, in calling the attention of the committee to this subject, expressed his regret that it had not been decided when under consideration five years ago. On the present occasion he should not take up much of the time of the committee, as he anticipated some objections to his proposition. Where the reputation of his country was concerned, as in cases where opportunities had occurred of purchasing valuable collections in science or art, calculated to enlighten and improve the taste of the people, even under the pressure of war, the House had never shown an unwillingness to listen to any applications made to them on that account. What large additions had been made to the public stock of valuable monuments of this description in the late French war! He need only refer to the Lansdown manuscripts; and what was more analogous to the present case, the Townleian collection of marbles purchased in 1795, when the war was but recently begun, and there was no prospect of its being soon finished. He wished to remind the House what a large vote had been given in the last session for a national monument to commemorate the glorious battle of Waterloo. In the present session, the House had also voted a monument in commemoration of the victory of Trafalgar, though long since past. He made these preliminary observations, in order to meet the objections of economy, which, he conceived, did not apply in this case. By declining to purchase the Elgin marbles, the public must renounce all right in the thing, and leave my lord Elgin at liberty to deal with any person who offers to purchase. The sort of mixed claim which the public had on lord Elgin, was, he conceived, of this description – they had not a right to take his collection from him by force; but they had a right of preemption at a fair price, and to say that it should not be taken out of this country. If he had not heard from gentlemen that it was their intention to oppose the present grant, he should not have thought it necessary – supposing the things good in themselves – to press upon the House, of what great consequence it was to every country, to promote public taste, and public refinement. How could these be better promoted than by making the greatest examples of excellence their own, for the benefit of the public? With respect to the manner in which the Elgin marbles had been acquired, the object certainly could not have been attained, had lord Elgin not been a British ambassador; but it was not solely as a British ambassador that he obtained them. No objection had ever been made to the operations of lord Elgin, either by the government, at Constantinople, or the local authorities; nor did it appear that any person had ever been disgraced or superseded on that account. Not only the local authorities of Athens were favourable, but the natives both Turks and Greeks, assisted as labourers. He had to state confidently that in all the examinations before the committee, of persons who had been at Athens, either at the period of lord Elgin's operations, or shortly afterwards, the uniform tenour of the evidence was, that the natives were

not only instrumental in carrying the firmaun into execution, but even pleased with it as the means of bringing money among them. He could therefore say, that there was nothing like spoliation in the case, and that it bore no resemblance to those undue and tyrannical means by which the French had obtained possession of so many treasures of art, which he rejoiced to see again in the possession of their rightful owners. A notion prevailed among some gentlemen, that these treasures also should be restored to their original owners. But how was this to be done? Were they to be taken as public property? Though we had a right of pre-emption, we had no right to take them away from lord Elgin without compensation. Did they mean that they should be purchased from lord Elgin, for the purpose of being shipped back to those who sat no value on them? Were not these works in a state of constant dilapidation and danger before their removal? The climate was no doubt less severe than our northern one; but still they were then making rapid strides towards decay, and the natives displayed such wanton indifference as to fire at them as marks. They had also been continually suffering, from the parts carried off by enlightened travellers. The greatest desire, too, had been evinced by the government of France to become possessed of them. We found them however here. The public had a right to bargain for them; and it would be a strange neglect of the policy pursued by the House of Commons in all times, and especially during the late war, if they neglected to become possessed of them. With respect to the price, in all works of art, the value might be said to depend on caprice. The most eminent artists had been consulted by the committee; by many they were classed above, and by others little below the highest works obtained since the restoration of art; and for forming a school of art they were considered as absolutely invaluable. The House had some actual data to guide them in the price given for the Townley collection. In point of number, the age to which they belonged, the place from which they were brought and the authenticity of the collection, there could be no doubt that they ranked considerably higher than the Townleian collection. If the Townleian collection was worth £20,000 this was worth at least the £15,000 additional proposed to be given. There was at least one foreign prince extremely desirous of purchasing this collection. The opportunity would not again recur. In no time had so large, so magnificent, and so well authenticated a collection of works of art of the best time, been produced, either in this or in any other country. In Italy the works of ancient art were found in excavations at different places and different times. But here we had at once the whole of the ornaments of the most celebrated temple of Athens. There was another mode of valuing the collection, the expense incurred in making it. He had no doubt that the sum proposed to be given fell considerably within the expense actually incurred by lord Elgin, exclusive of interest. In 1811, £30,000 had been offered by Mr Perceval, provided lord Elgin could make it appear that his expense amounted to that sum. But considerable additions had been made since 1811, no fewer than eighty cases, containing some of the best works had been since received, and persons who were judges had no doubt that such additions greatly exceeded in value £5,000. Under all these circumstances, he should move, 'That £35,000 be granted to his majesty, for the purchase of

the Elgin marbles, and that the said sum be issued and paid without any fee or other deduction whatsoever.'

Mr *Curwen* opposed the grant. He cordially joined the hon. gentleman in his sentiments respecting the importance of works of art. The hon. gentleman had referred to the monuments voted for the victims of Waterloo and Trafalgar. He hoped, however, in the present situation of the country, that the House would retrace their steps. No monument could add to the transcendent glory of those victories, or of the heroes engaged in them. A statement had been made the other night, that the expenses of the country exceeded the revenue by nearly £17,000,000. He wished it were possible to controvert this statement. In such a state was it fit to make purchases of this description, however gratifying to a few individuals, at the expense of the nation? He was afraid that we were fast approaching to that course of extravagance with respect to the public money, which had brought to decay the countries where these works of art were produced. Whatever imputations of want of taste and feeling might be thrown out against him, he would say that the House were bound, however much they admired this collection, and it was admired by every man in the House, to refrain from making the purchase at the present moment. Retrenchments of a very different magnitude from any yet witnessed must necessarily be made.

Mr *J. W. Ward* was as adverse to idle expenditure as the hon. gentleman himself could be, and thought we should not seek occasions for it; yet he considered the present an opportunity of benefiting the public that could not occur again: and it was precisely because it was not against the principle of economy that he voted for the measure. As to the

spoliation of Greece that had been so much complained of, no one could be more unwilling than he was that these sacred relics should be taken from that consecrated spot, where they had excited the enthusiasm of ages; no one could have a greater respect than himself for the feelings of nations; but these objects were lying in their own country in a course of destruction: and he wished to consult the feelings of that country by any means short of the actual destruction of specimens so precious. As to the price that had been proposed, it was pretty clear that foreign princes would go to it, if we did not; and it certainly did not exceed the value of the articles.

Mr *Hammersley* said, he should oppose the resolution on the ground of the dishonesty of the transaction by which the collection was obtained. As to the value of the statues, he was inclined to go as far as the hon. mover, but he was not so enamoured of those headless ladies as to forget another lady, which was justice. If a restitution of these marbles was demanded from this country, was it supposed that our title to them could be supported on the vague words of the firmaun, which only gave authority to remove some small pieces of stone? It was well known that the empress Catharine had entertained the idea of establishing the Archduke Constantine in Greece. If the project of that extraordinary woman should ever be accomplished, and Greece ranked among independent nations with what feelings, would she contemplate the people who had stripped her most celebrated temple of its noblest ornaments? The evidence taken before the committee disproved the assertion that the Turkish government attached no value to these statues. Lord Elgin himself had not been able to gain access to them for his artists, for less than five guineas a

day. The member for Northallerton (Mr Morris) had stated before the committee, that when he had inquired of the governor of Athens whether he would suffer them to be taken away, he had said, that for his own part he preferred the money which was offered him to the statues; but it would be more than his head was worth to part with them. He had also stated, that the pieces thrown down were certainly liable to injury, but that the others were only subject to the waste of time. The Turks (the same witness said) were not in the habit of shooting at them, nor had he heard any instance of that kind. But whether the Turks sat any value on them or no, the question would not be altered, as his objection was founded on the unbecoming manner in which they had been obtained. It was in the evidence of the noble earl himself, that at the time when he had demanded permission to remove these statues, the Turkish government was in a situation to grant any thing which this country might ask, on account of the efforts which we had made against the French in Egypt. It thus appeared that a British ambassador had taken advantage of our success over the French to plunder the city of Athens. The earl of Aberdeen had stated that no private traveller would have been able to have obtained leave to remove them. But the most material evidence respecting the manner in which these statues had been obtained, was that of Dr Hunt, who stated, that when the firmaun was delivered to the waywode, presents were also given him. It thus appeared that bribery had been employed, and he lamented that the clergyman alluded to should have made himself an agent in the transaction. It was his opinion that we should restore what we had taken away. It had been computed that lord Elgin's

expenses had been £74,000, of which, however, £24,000 was interest of the money expended. A part of the loss of this sum should be suffered to fall on lord Elgin, and a part on the country. It was to be regretted that the government had not restrained this act of spoliation; but, as it had been committed, we should exert ourselves to wipe off the stain, and not place in our museum a monument of our disgrace, but at once return the bribe which our ambassador had received, to his own dishonour and that of the country. He should propose as an amendment, a resolution, which stated – 'That this committee having taken into its consideration the manner in which the earl of Elgin became possessed of certain ancient sculptured marbles from Athens, laments that this ambassador did not keep in remembrance that the high and dignified station of representing his sovereign should have made him forbear from availing himself of that character in order to obtain valuable possessions belonging to the government to which he was accredited; and that such forbearance was peculiarly necessary at a moment when that government was expressing high obligations to Great Britain. This committee, however, imputes to the noble earl no venal motive whatever of pecuniary advantage to himself, but on the contrary, believes that he was actuated by a desire to benefit his country, by acquiring for it, at great risk and labour to himself, some of the most valuable specimens in existence of ancient sculpture. This committee, therefore, feels justified, under the particular circumstances of the case, in recommending that £25,000 be offered to the earl of Elgin for the collection in order to recover and keep it together for that government from which it has been improperly taken, and to which this

committee is of opinion that a communication should be immediately made, stating, that Great Britain holds these marbles only in trust till they are demanded by the present, or any future, possessors of the city of Athens, and upon such demand, engages, without question or negociation, to restore them, as far as can be effected, to the places from whence they were taken, and that they shall be in the mean time carefully preserved in the British Museum.'

Mr *Croker* was desirous not to take up the time of the committee by entering into the discussion, but he could not help remarking upon one or two of the statements which the last speaker had drawn from the evidence, by reading one part of it, and omitting others which should have been taken in connexion. He had never heard a speech filled with so much tragic pomp and circumstance, concluded with so farcical a resolution. After speaking of the glories of Athens, after haranguing us on the injustice of spoliation, it was rather too much to expect to interest our feelings for the future conqueror of those classic regions, and to contemplate his rights to treasures which we reckoned it flagitious to retain. It did seem extraordinary that we should be required to send back these monuments of art, not for the benefit of those by whom they were formerly possessed, but for the behoof of the descendants of the empress Catherine, who were viewed by the hon. gentleman as the future conquerors of Greece. Spoliation must precede the attainment of them by Russia; and yet, from a horror at spoliation, we were to send them, that they might tempt and reward it! Nay, we were to hold them in trust for the future invader, and to restore them to the possession of the conqueror, when his rapacious and bloody work was executed.

Our museum, then, was to be the repository of these monuments for Russia, and our money was to purchase them in order that we might hold them in deposit till she made her demand. The proposition, he would venture to say, was one of the most absurd ever heard in that House. Considerations of economy had been much mixed up with the question of the purchase; and the House had been warned in the present circumstances of the country, not to incur a heavy expense merely to acquire the possession of works of ornament. But who was to pay this expense, and for whose use was the purchase intended? The bargain was for the benefit of the public, for the honour of the nation, for the promotion of national arts, for the use of the national artists, and even for the advantage of our manufactures, the excellence of which depended on the progress of the arts in the country. It was singular that when 2500 years ago, Pericles was adorning Athens with those very works, some of which we are now about to acquire, the same cry of economy was raised against him, and the same answer that he then gave might be repeated now, that it was money spent for the use of the people, for the encouragement of arts, the increase of manufactures, the prosperity of trades, and the encouragement of industry; not merely to please the eye of the man of taste, but to create, to stimulate, to guide the exertions of the artist, the mechanic, and even the labourer, and to spread through all the branches of society a spirit of improvement, and the means of a sober and industrious affluence. But he would go the length of saying, that the possession of these precious remains of ancient genius and taste would conduce not only to the perfection of the arts, but to the elevation of our national character,

to our opulence, to our substantial greatness. The conduct of the noble earl, who by his meritorious exertions, had given us an opportunity of considering whether we should retain in the country what, if retained, would constitute one of its greatest ornaments, had been made the subject of severe and undeserved censure. No blame had, however, been shown to attach to it after the fullest examination. One of the objects, and the most important object, for which he wished the institution of a committee was, that the transactions by which those works of art were obtained, and imported into this country, might stand clear of all suspicion, and be completely justified in the eyes of the world, and that the conduct of the noble lord implicated might be fully investigated. He (Mr C.) was entirely acquainted with the noble lord before he became a member of the committee, and could, of course, have no partialities to indulge. What he said for himself, he believed he might say for the other members with whom he acted. They were all perfectly unprejudiced before the inquiry commenced, and all perfectly satisfied before its conclusion. They had come to a unanimous opinion in favour of the noble lord's conduct and claims, and that opinion was unequivocally expressed in the report which was the result of their impartial examination. With regard to the spoliation, the sacrilegious rapacity, on which the last speaker had descanted so freely, he would say a few words in favour of the noble lord, in which he would be borne out by the evidence in the report. The noble lord had shown no principle of rapacity. He laid his hand on nothing that could have been preserved in any state of repair: he touched nothing that was not previously in ruins. He went into Greece with no design to commit

ravages on her works of art, to carry off her ornaments, to despoil her temples. His first intention was to take drawings of her celebrated architectural monuments, or models of her works of sculpture. This part of his design he had to a certain extent executed, and many drawings and models were found in his collection Nothing else entered into his contemplation, till he saw that many of the pieces of which his predecessors in this pursuit had taken drawings had entirely disappeared, that some of them were buried in ruins, and others converted into the materials of building. No less than eighteen pieces of statuary from the western pediment had been entirely destroyed since the time when M. de Nointel, the French ambassador, had procured his interesting drawings to be made; and when his lordship purchased a house in the ruins of which he expected to find some of them, and had proceeded to dig under its foundation with such a hope, the malicious Turk to whom he had given the purchase-money observed, 'The statues you are digging for are pounded into mortar, and I could have told you so before you began your fruitless labour.' [Hear, hear!] – Ought not the hon gentleman who had spoken so much about spoliation to have mentioned this fact? Ought he not to have stated that it was then, and not till then, that lord Elgin resolved to endeavour to save what still remained from such wanton barbarity? Had he read the report, and did he know the circumstances without allowing any apology for the noble earl? Did he not know that many of the articles taken from the Parthenon, were found among its ruins? More than one-third of that noble building was rubbish before he touched it. The hon. member (Mr Hammersley) had referred to the

evidence of the member for Northallerton (Mr Morrit); but while he quoted one part of it, he had forgotten another, by which that quotation would have been explained and qualified. He had visited Athens in 1796; and when he returned five years afterwards, he found the greatest dilapidations. In his first visit he stated, that there were eight or ten fragments on the pediment, with a car and horses not entire, but distinguishable: but when he returned, neither car nor horses were to be seen, and all the figures were destroyed but two. If the hon. member, whose statement he was combating, had read the evidence carefully, he would have seen that lord Elgin interfered with nothing that was not already in ruins, or that was threatened with immediate destruction. The temple of Theseus was in a state of great preservation, and, therefore, proceeding on this principle, he had left it as he found it, and only enriched this country with models and drawings taken from it. Much had been said of the manner in which lord Elgin had prostituted his ambassadorial character to obtain possession of the monuments in question. There was no ground for such an imputation. Not a piece had been removed from Athens till lord Elgin had returned, and of course till his official influence ceased. Signor Lucieri was even now employed there under his lordship's orders; and was he still prostituting the ambassadorial character? When his lordship was a prisoner in France, the work was still going on; and was he then prostituting the ambassadorial character? His lordship had remained after his return at his seat in Scotland; and was the character of ambassador injured in his person during his retirement? He (Mr Croker) might have shown some warmth in defending the opinion of the committee, and removing the imputation thrown upon the noble person whose character had been attacked by the hon. member: but he hoped he would be excused, when the nature of the charges which had excited him were considered. – He could not sit in his place, and hear such terms as dishonesty, plunder, spoliation, bribery, and others of the same kind, applied to the conduct of a British nobleman, who was so far from deserving them that he merited the greatest praise, and to the nature of transactions by which so great a benefit was conferred upon the country, without any ground for a charge of rapacity or spoliation. But if the charges of improper conduct on lord Elgin's part were groundless, the idea of sending them back to the Turks was chimerical and ridiculous. This would be awarding those admirable works the doom of destruction. The work of plunder and dilapidation was succeeding with rapid strides, and we were required again to subject the monuments that we had rescued to its influence. Of twenty statues that decorated the western pediments of the Parthenon, only seven miserable fragments were preserved: yet this part of the building was almost perfect at the beginning of last century; now only a few worthless pieces of marble were preserved – he called them worthless, not as compared with the productions of art in other countries, but in comparison with what had been lost. They would, however, remain to animate the genius and improve the arts of this country, and to constitute in after times a sufficient answer to the speech of the hon. member, or of any one else who should use his arguments, if indeed such arguments could be supposed to be repeated, or to be heard beyond the battle hour in which they were made.

Mr Serjeant *Best* conceived that lord

Elgin had not acted as he ought to have done, whatever opinion might be entertained of the works of art which he had been the means of importing into this country. He regarded the improvement of national taste much, but he valued the preservation of national honour still more. He could not approve of a representative of his majesty laying himself under obligations to a foreign court, to which he was sent to watch the interests and maintain the honour of the country. Such an officer should be independent, as by his independence alone he could perform his duty. He had obtained the firmaun out of favour, and had used it contrary to the intention with which it was granted. What would be thought of an ambassador at an European court, who should lay himself under obligations by receiving a sum to the amount of £35,000? But even the firmaun lord Elgin had obtained did not warrant him to do as he had done. The firmaun could do nothing without bribery. Could the words in which it was written admit the construction that was put upon them? It merely gave a power to view, to contemplate and design them. Did this mean that these works were to be viewed and contemplated with the design of being pulled down and removed? Lord Elgin himself did not say that he had authority to carry off anything by means of the firmaun. His lordship was himself the best interpreter of the instrument by which he acted, and he was here an interpreter against himself. If he erred, he erred therefore knowingly, though his design might be excusable or praiseworthy. Dr Hunt's evidence had been quoted, to show that his lordship had authority from the waywode of Athens for what he had done, but his words would not bear such an interpretation. Dr Hunt said only that the waywode was induced to allow the construction put upon the instrument by lord Elgin. The powerful argument by which the waywode was induced to allow the construction alluded to, consisted in a present of a brilliant lustre, fire-arms, and other articles of English manufacture. But were these the arguments that ought to have been used by a British ambassador? Was he to be permitted to corrupt the fidelity of a subject of another state – the servant of a government in alliance with our own, and under obligations to us? But it had been said that if the works of art had not been brought here, they would have been destroyed by the Turks. This would not have been the alternative. The Turks would have been taught to value these monuments, had they seen strangers admiring them, and travellers coming from distant countries to do them homage. They could not but now learn their value, after they were deprived of them, by hearing that £35,000 had been paid for them to the person who imported them to England. It had been said that lord Elgin would advance the arts by lodging these remains of antiquity in a country where eminence in arts was studiously attempted. This he denied, or at least thought doubtful. Such works always appeared best in the places to which they were originally fitted. Besides, with this example of plunder before their eyes, the Turks would be a little more cautious in future whom they admitted to see their ornaments. These marbles had been brought to this country in breach of good faith. He therefore could not consent to their purchase, lest by so doing he should render himself a partaker in the guilt of spoliation. He did not object to the bargain on the ground of economy, but of justice.

Mr *Wynn* was not aware of the

transaction being so flagitious as it was said to be. He equally disliked the idea being entertained that we had got them by bribery. Every person who knew the Turkish character must be sensible that when they gave any thing away it was with the view of receiving an equivalent. He could not condemn the transaction on the ground of the marbles being a gift from a foreign government, and therefore affording a bad precedent; for he did not think that a gift of £35,000 purchased at an expense of £64,000 was a precedent likely to be much followed. On the principle of economy he knew it was the duty of the House to act, but economy was often ill-judged, and very much misapplied. Considering them a valuable accession in every point of view, and that the same opportunity might never recur, he had no objection to the grant.

Sir *J. Newport* would vote against the motion, even if the country were in affluent circumstances, on account of the unjustifiable nature of the transaction by which the marbles in question were acquired.

Mr *C. Long* said, he was ready to agree in all the objections founded upon the unfitness of the time for any acts of lavish expenditure; but the present was an occasion, which could not again present itself, of acquiring for the country these exquisite specimens of art. It was fair to say that the purchase of these precious remains of antiquity was for the gratification of the few, at the expense of the many. The amendment of the hon. gentleman was somewhat inconsistent with his professions of economy, for he proposed to give £25,000 to lord Elgin, for obtaining these marbles dishonestly, and then to send them back to those who would not thank them for their trouble.

Lord *Milton* was aware that an apology might be expected from all those who objected to a grant that was to put the country in possession of these invaluable monuments of ancient art. He could not, however, agree that they had been acquired consistently with the strict rules of morality. They appeared to him to have been obtained by lord Elgin through his influence as ambassador from this country, and it was not unnatural that the Turkish government should view with suspicion a national purchase arising out of such circumstances. The objection to the purchase he should deem niggardly and ill-advised at any other time; but the present was one of peculiar distress, and one in which the want of subsistence was the cause of riot and disturbances in many parts of the country.

Mr *P. Moore* said, the hon. gentleman who had talked of this being the last opportunity, reminded him of the auctioneer's cry of 'going, going, gone.' He desired to know whether any offer had been made for these marbles by a foreign power; and whether they were not in fact under sequestration at present by government for a debt due to the Crown by lord Elgin.

Mr *Brougham* considered that there was no doubt as to the desirableness of our possessing these interesting monuments, from their general tendency to improve the arts. The only question upon which he hesitated was, whether we could afford to buy them. The purchase-money, they were told, was but £35,000; but he apprehended that, when purchased, it would be necessary to build a proper receptacle for them, and the whole expense might be estimated at 70 or £80,000. Had we, then, this money at present in our pockets, with which to gratify ourselves by so desirable a possession? The stronger the temptation was to this purchase, the greater satisfaction he felt in redeeming his share

of the pledge given to the country, that
no unnecessary expenditure should be
incurred.

Mr *J. P. Grant* declared in favour of
the original motion, observing, that that
would be a mistaken economy, as well as
bad taste, which would deprive this
country of such valuable works of art as
lord Elgin had collected.

The House divided: For the original
Motion, 82; Against it, 30.

Index